IMAGES
of America

NEW PALTZ

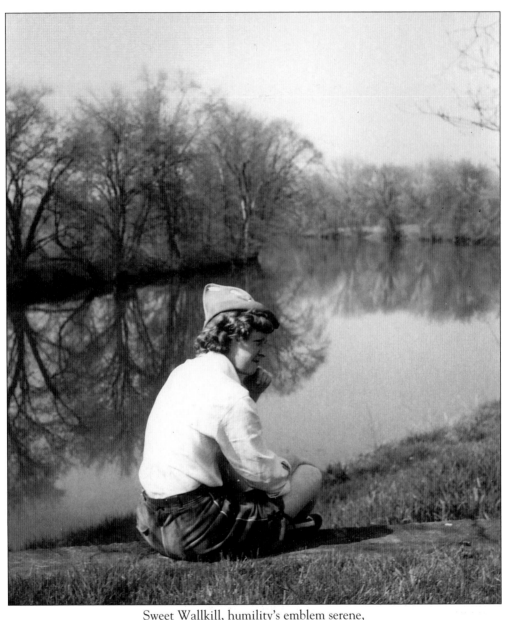

Sweet Wallkill, humility's emblem serene,
With a music of ripples and meadows of green
With willows and elm-boughs half sad and half gay,
Drooping over to kiss the white foam flakes away.
Thy vale seems a garden hedged 'round by the hills,
Whose loveliness pleases, and quiet instills.
The distant blue Catskills like battlement towers
Ward off the chill north wind from blighting thy flowers.
While Shawangunk's bleak bulwark breaks storms from the west,
That the homes of the happy all peaceful may rest.

—From "Wallkill," a poem written for the *New Paltz Times*, August 8, 1861.

IMAGES
of America

NEW PALTZ

Carol A. Johnson and Marion W. Ryan
of the
Haviland-Heidgerd Historical Collection
Elting Memorial Library

ARCADIA

Copyright © 2001 by Carol A. Johnson and Marion W. Ryan.
ISBN 0-7385-0873-X

First printed in 2001.

Published by Arcadia Publishing,
an imprint of Tempus Publishing, Inc.
2A Cumberland Street
Charleston, SC 29401

Printed in Great Britain.

Library of Congress Catalog Card Number: 2001090266

For all general information contact Arcadia Publishing at:
Telephone 843-853-2070
Fax 843-853-0044
E-Mail sales@arcadiapublishing.com

For customer service and orders:
Toll-Free 1-888-313-2665

Visit us on the internet at http://www.arcadiapublishing.com

On the cover: Members of the Elting Harp family pose in 1904 with Die, their faithful bird dog. They are, from left to right, Delia, Carolyn Tamney Harp holding baby Harry on her lap, Helen, Frank (with the white bow), Warren (standing), Elting Harp Sr., and Peter. Two younger children, Marion and Elting Jr., had not yet been born. (Courtesy of Marion Harp Deyo.)

This book is dedicated to William Heidgerd and Irene H. Martin.

CONTENTS

Introduction 7

1. A Town in Transition 9

2. Gaining an Education 35

3. Life on Main Street 61

4. Work, Play, and Worship 87

Acknowledgments 127

Suggested Readings 128

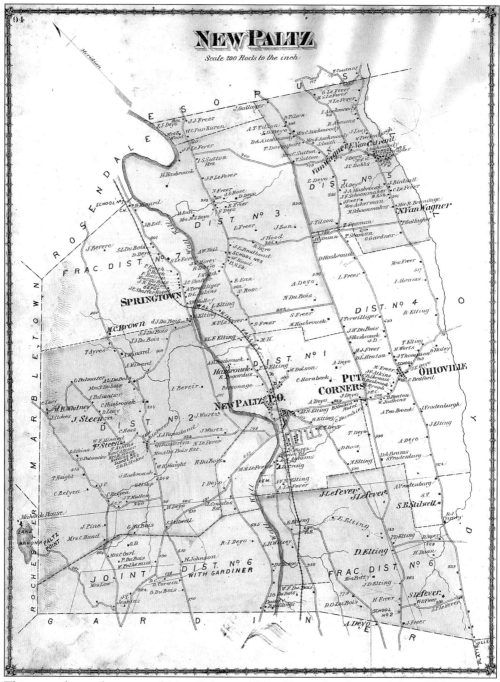

This map shows the town of New Paltz in 1875. (From the *County Atlas of Ulster, New York*, 1875.)

INTRODUCTION

A small group of French Huguenot refugees chose well when they settled the fertile Wallkill River Valley site that became the town of New Paltz. Local resident Isaac LeFever describes the town over a century later in a document prepared for the surveyor general, dated January 25, 1798. The following excerpts from a section titled "Remarks and Observations" have been selected and edited for clarity.

"This town retains its original name since the first settlement which was by eight families of French extraction and was first settled a few years before the grant for their patent which was in the year 1677. Is pleasantly situated on the West Bank of Hudson's River with convenient landing places and good roads thro' the same. . . .

"The soil in general is fertile and yielding plenty of Wheat, Rye, Indian Corn, Buckwheat, Oats, Flax, Potatoes, and all kinds of vegetables peculiar to our climate. Is well watered by the Wall Kill or Paltz River which runs thro' a large body of intervale land in a N.E. direction as laid down on the map. . . . proportion of improved to uncultivated land is about 2 to 5 and the timber chiefly Oak, Walnut, Chestnut, Maple, Elm, Ash . . . the Dogwood flowers are in June, Strawberry flowers in the latter end May. Peach and Apple tree flowers on the 10th of May. The swallows generally appear on the 20th of April and disappear on the first of September. Earliest frost in the Fall is about the middle of September and latest in the Spring is commonly the 10th of April. . . . We have but one kind of insects injurious to trees which is the common caterpillar. The Hessian fly has proved very destructive to our wheat. . . .

"The town of New Paltz has upwards of 350 houses of which about 22 are licensed taverns, 15 schoolhouses, 3 meeting houses. About 2/3 of the town are Reformed and 1/3 Methodists and Baptists and some Quakers, etc. Our town has 13 Grist Mills & 20 Saw Mills. Physicians we have four. Lawyers we have none! We have two Ministers of the Gospel and about 12 Schoolmasters. The use of Oxen is increasing very fast about 2/5 are Oxen & 3/5 Horses. The diseases most prevalent are the fever & ague in the month of July and August, also the remiting fever, pleurises, and apoplexy. The inhabitants of the town are in general independent, plain in their dress, not ambitious for promotion, rather inclined to backwardness than courteous especially to strangers. At the same time very hospitable to those that appear deserving their charity or esteem. They are a people very tenacious for their constitutional rights, civil and religious, as also to their usual customs & habits."

Change came slowly to this traditional close-knit agricultural community. It was not until after the American Revolution that English completely displaced both the written and spoken French and Dutch languages. The town, which had hired its first French-speaking schoolmaster in 1689 to teach classes in the church, came to value higher education. In the early 1800s, a classical school was established, followed by the impressive academy that educated boarding students as well as local day students. Predecessors of the present State University of New York at New Paltz included the New Paltz Academy, which later evolved into the New Paltz Normal School, then the New Paltz State Teachers College. Suddenly there were many new faces in town. Student and faculty life became interwoven with the business, political, cultural, and social life of the town.

In the 1860s, more than 100 local young men left the area for the first time to fight in the Civil War. By 1868, two local newspapers competed for subscribers. Both editors covered local news in informative columns. A few years later railroad tracks were laid through town. The Wallkill Valley Railroad connected New Paltz to points north and south, carrying passengers, produce, and mail.

In 1897, trolley tracks were laid between New Paltz and Highland. Many laborers associated with this enterprise were Italian immigrants. Some stayed in the area after the project was completed. The trolley was exciting and much faster than horses, but not nearly as fast or convenient as the automobile. The problem-plagued trolley company was out of business by 1925.

In the late 1800s, the scenic Shawangunk Mountains on the western horizon became a recreational destination. The Mohonk and Minnewaska mountain houses, built on the edges of two glorious mountain lakes, opened for business. Their success helped to spawn a boardinghouse industry throughout the valley. Farmers realized that people were willing to pay for country pleasures and began to rent out rooms in their large homes. More new faces appeared in town. Advertising for these boardinghouses and summer festivals took flight. One brochure promised "The best food grown in home gardens and dairy products from accredited herds makes eating an Epicurean rite. Pure, fresh mountain air spurs jaded appetites and woos lost sleep."

In 1894, a concerned group recognized the unique historic value of the original stone houses on Huguenot Street. They founded a local historical society that began the process of preserving a significant number of buildings as museums. This early sensitivity to preservation proved timely. Maps were being redrawn to include new grids designed for residential housing in the village. Out-of-town entrepreneurs had already arrived to finance and construct large commercial buildings along Main Street. A volunteer fire department established in 1889 has been active ever since. Other service organizations as well as social clubs attracted strong and loyal memberships.

With change escalating, the town took on a new vitality and character. By 1900, there was no longer any simple way to describe New Paltz. Many of the old labels no longer applied. In 2001, New Paltz continues to resist easy definition. In this photographic essay, we seek to engage our readers in the life of a small, complex town.

One

A Town in Transition

DIE PFALZ.

The names of the 12 Huguenots associated with the earliest settlement of New Paltz are Louis DuBois, Christian Deyo, Abraham Hasbrouck, Andre LeFevre, Jean Hasbrouck, Pierre Deyo, Louis Bevier, Anthoine Crespell, Abraham DuBois, Hugo Frere, Isaac DuBois, and Simon LeFevre. Their families were part of the group of French Protestants who fled to Die Pfalz during the religious persecutions of Louis XIV in the 17th century. New Paltz derives its name from their place of refuge, located along the Rhine River near Speyer and Mannheim in the Palatinate region of Germany.

Twelve Huguenots bargained for land extending from the Shawangunk Mountains to the Hudson River. In exchange for an assortment of material goods, including 40 kettles, 40 oars, and 100 knives, a group of Native American men and women referred to as Esopus Sachems drew their signature marks on the 1677 deed. Lord Andross, the governor of New York, granted the settlers a formal patent four months later. (Photograph detail from *The Indian Deed*, by Erma DeWitt.)

The Huguenot Patriotic, Historical, and Monumental Association bought the Jean Hasbrouck house in 1899. For over a century, it has been a museum dedicated to the history of the community. The stone monument placed in front of the house lists the names of the 12 patentees, or founders, of New Paltz. The association changed its name to the Huguenot Historical Society in 1953.

This early map drawn by August Graham shows linear boundary lines of the original 39,683-acre tract. "Mogonick" on the southwest evolved into Mohonk. Now known as Sky Top, it is the only corner point on the map that remains in the town of New Paltz. By 1845, major sections had been carved off to create the town of Lloyd, as well as parts of Esopus and Rosendale. (Photograph by H.L. Schultz.)

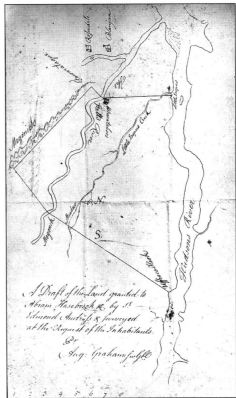

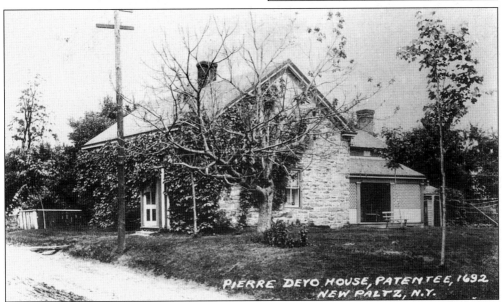

Pierre Deyo built the first stone house on Huguenot Street in 1692. Like the other houses on the street, it was built in the rural Flemish style using native limestone held in place with puddled clay. Remodeled in 1894 by Deyo's fifth great-grandson, Abraham Deyo Brodhead, the modest one-and-a-half-story homestead was enlarged and transformed into a rather grand Victorian home.

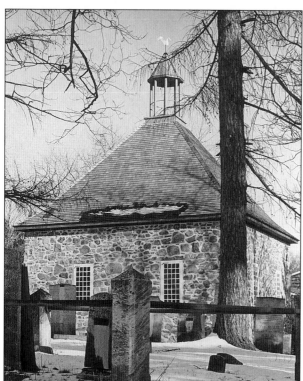

The cupola delivered by helicopter in 1972 to be placed atop the reconstructed French Church capped seven years of research, planning, and fund-raising by the Huguenot Historical Society. The 1717 French Church served the community as both church and school until 1772. The cemetery in the foreground is the final resting place for many of the original settlers. Also buried here are veterans of both the American Revolution and the War of 1812.

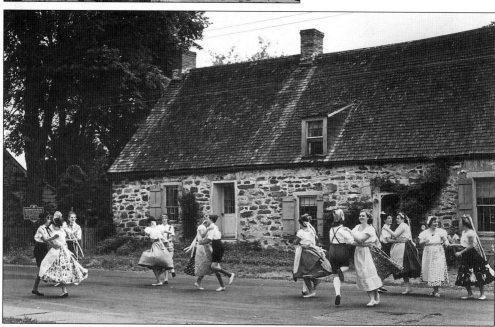

Children dance in the street in front of the Abraham Hasbrouck house. Community residents, many of them dressed in treasured family heirlooms, demonstrate old crafts nearby. Begun in 1951 as a fund-raiser for the Reformed Church, the annual Stone House Day Festival, with its pageantry and costumed tour guides, has attracted thousands of people to Huguenot Street over the years.

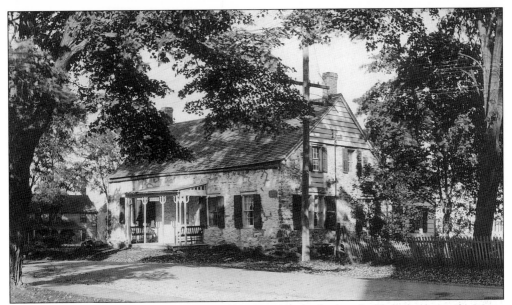

Patentee Hugo Freer's eldest son, Hugo (1668–1732), built this dwelling for his wife, Maria Anna LeRoy, and their 13 surviving children. The Freer House stands at the northern end of the historic district on Huguenot Street. Freer's descendant Charles Lang Freer was the benefactor of the Smithsonian Institution's Freer Gallery of Art, in Washington, D.C. (Courtesy of William and Sally Rhoads.)

Trained as an architect and artist before emigrating from Sweden, Ivar Evers moved his family to the Abraham Hasbrouck House on Huguenot Street in 1919. Passionate about his new home, garden, and surroundings, Evers began to create paintings of familiar mid-Hudson Valley landscapes and buildings. The Dorsky Art Museum on the State University of New York New Paltz campus now owns many of his regional watercolors and oils. (Photograph by Erma DeWitt.)

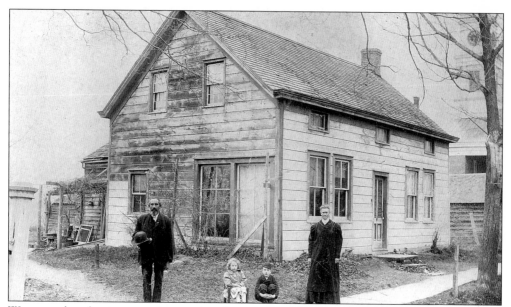

Wagon maker, furniture repairman, church sexton, and handyman Cyrus D. Freer (1845–1927) kept a detailed diary for at least 20 years. He joins his third wife, Mary Jane Snyder, and their children Lauretta and Hugo for this 1908 family portrait in front of their Huguenot Street home. Mary Jane Freer voted in the village election in 1918; the first and only New Paltz woman to take advantage of her rights under the new equal suffrage law.

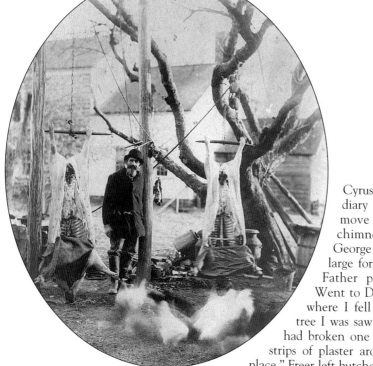

Cyrus Freer's May 16, 1903 diary entry begins, "Helped move stove. Fixed hole in chimney at bank. Was to George Duboises funeral . . . large for a week day. The Rev. Father preached a good one. Went to Dr. Green about my side where I fell on root of old willow tree I was sawing up in our swamp. I had broken one of my ribs . . . he put strips of plaster around me to hold it in place." Freer left butchering for another day.

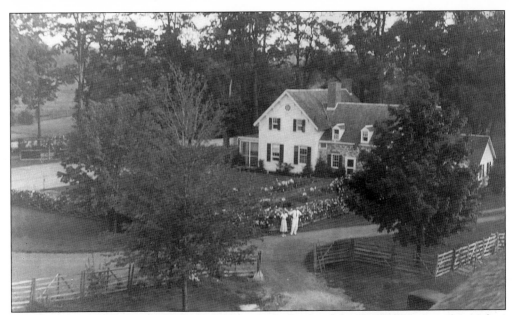

Within two generations, the little settlement on the banks of the Wallkill became the nucleus of a growing community. Families spread out in all directions as patent divisions made land available. Abraham Elting built this 1759 farmhouse just north of Huguenot Street. In 1979, Gordon and Joanne Kreth converted what once had been a farmhouse into the Locust Tree Inn restaurant. Surrounding farmland is now the New Paltz Golf Course.

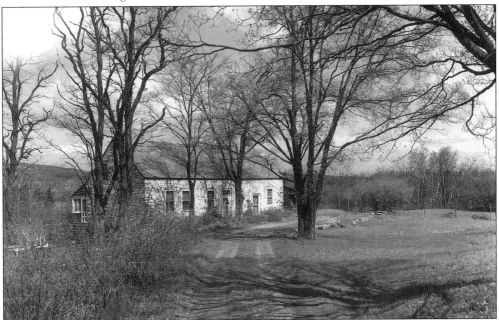

Madame Martha advertised palm readings at Wally Waldron's House of Magic. Customers traveled just north of the village to this stone house for readings. Elton LeFevre bought the house from them in 1931. One day his twin sons discovered a caged raccoon in the yard. Trapped in the Adirondacks, the raccoon was the first of many gifts delivered by an uncle who liked to surprise his nephews each time he visited. (Photograph by Erma DeWitt.)

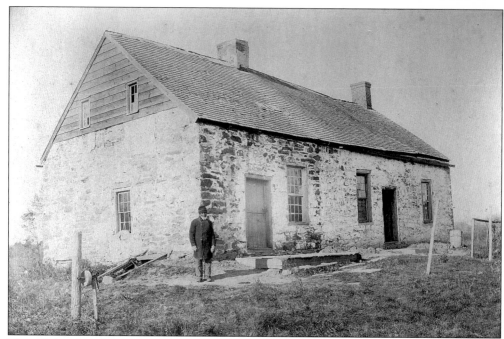

This 60-foot-long house, now known as White Duck, is the only one that remains of four stone houses built by Daniel LeFevre (1725–1800) and his immediate family. Settling the area four miles north of the village "at Bontekoe on East banck of Wallkill" in the early 18th century, the extended family became known as the Bonticou LeFevres. LeFevre's grandson Josiah P. LeFevre lived here until 1850.

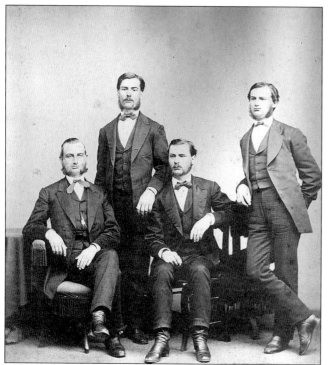

Five of Josiah P. LeFevre's sons were born in the stone house. Shown c. 1871, from left to right, are Peter, Moses, Ralph, and Isaac LeFevre. After serving in the Civil War, Peter LeFevre remained south as a fruit grower. Sister Jane's 1878 diary entry reads, "Peter died of yellow fever Sept. 15 at Bartlett, Tenn. His widow with the children fled to us. Her father and myself have been with them for three weeks in quarantine in the stone house."

Brothers Johannes and Peter LeFevre graduated from Union College before enlisting with Company A of the 156th Regiment, New York State Volunteers. Johannes LeFevre (right) wrote home in October 1864: "I was quite severely wounded at the Battle of Cedar Creek. I am comparatively free from pain & quite comfortable indeed. I wish you would come on & see me." His father did visit briefly, but was not there when Johannes died in November in Virginia.

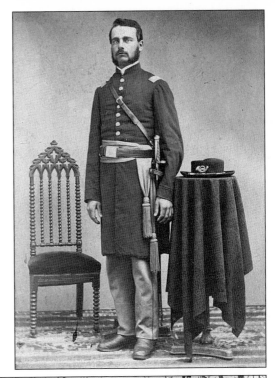

The year after the birth of his son Moses in 1849, Josiah P. LeFevre built this house on Old Kingston Road, now Route 32 North. His youngest son, Simon, was born in the house nine years later and continued to live and farm there until 1941. Simon LeFevre auctioned many household items and farm equipment as he was leaving, although the house remained in the LeFevre family.

The Vanderlyns stop by to visit at the DuBois home on Rural Avenue (now Route 208) in the early 1900s. Respected as a scientific farmer, Solomon DuBois (1836–1924) raised Holstein-Friesian cattle. He also tended a vineyard on the tract of land that had been in his family for seven generations. Louis DuBois received a 3,000-acre patent from Governor Dongan in 1688. Much of this land became the town of Gardiner in 1853.

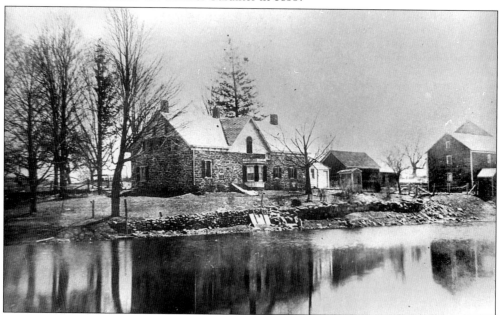

This farmyard was originally part of a 1,200-acre patent granted to the Freer family in 1715. Daniel Jansen completed construction of the stone house in 1776 on land purchased from the Freers. Owned by the Schreibers in the 1900s, the house burned down in 1951. The remaining foundation, located at the eastern end of Schreiber's Lane, was buried under the New York State Thruway three years later. (Courtesy of Margaret Coats.)

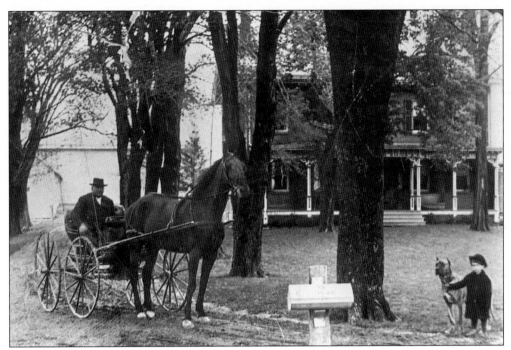

Derrick W. Eltinge Sr. built his substantial brick house, now located on Route 32 South, in 1836. Fourteen people lived here in 1855, including Mr. Eltinge and his second wife, Magdalene, six children, his brother, and five servants. Known as the Huguenot Bank's largest stockholder during the Civil War, the wealthy farmer owned two carriages and a pianoforte. He was assessed $6 on these holdings under a special war tax.

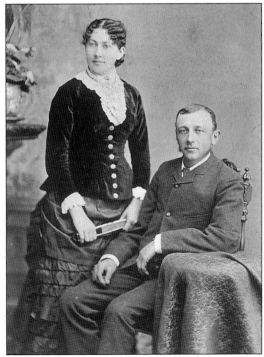

Derrick W. Eltinge Jr. (1847–1899) and his bride, Mary LeRoy (1851–1928), pose for their formal wedding portrait on February 10, 1876. The young couple remained on the Eltinge family homestead for four years before relocating to a farm near Clintondale. Eltinge became a serious fruit and berry farmer, immediately planting 1,200 peach trees, 3,500 grapevines, and 1,800 gooseberry bushes. He sent his produce to New York City, Philadelphia, and New Jersey by rail.

John Wynkoop (1827–1901) was born one week before all slaves were set free in New York State. Like most emancipated slaves, members of his family took the surname of their former owner, Gen. Derick Wynkoop, who resided in the house pictured below. John Wynkoop was one of the original trustees of the African Methodist Episcopal Church on Pencil Hill when it opened in 1871. His brother Jacob Wynkoop was the carpenter in charge of building the parsonage nearby.

This Federal-style brick house was built on top of the charred ruins of a 1742 stone house. A portion of an original stone wall remains, bearing the mark "anno 1745." The 1870 census has 18 members of the Edmund Eltinge family including their servants all living in this Plains Road homestead. Known as "the Locusts," the home has remained in the Eltinge family for eight generations. (Photograph by Jane Brodhead LeFevre Gerow.)

Edmund Eltinge's son (left) Capt. Peter Eltinge (1841–1877) was an organizer and officer of Company A of the 156th New York State Volunteer Regiment in the Civil War. For the part he played in the war, the local Grand Army of the Republic Post was named in his honor. His wife (right), Magdalene LeFevre Eltinge (1844–1932), lived 55 years after the death of her husband. Successfully continuing the business begun by him, "Maggie" Eltinge was Ulster County's only female insurance agent in 1877. She traveled alone by horse-drawn carriage to visit her customers; many of them lived on farms scattered throughout the countryside.

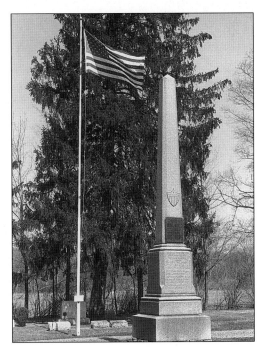

Peter Eltinge was instrumental in getting this monument erected in 1871. Honoring local soldiers who served in the Civil War, the monument stands at the western end of the New Paltz Rural Cemetery, on Plains Road. Although approximately 140 men and boys from the town served in the war, only 28 names are carved on the monument. Plans to include more names were never realized. (Photograph by Lauren Thomas.)

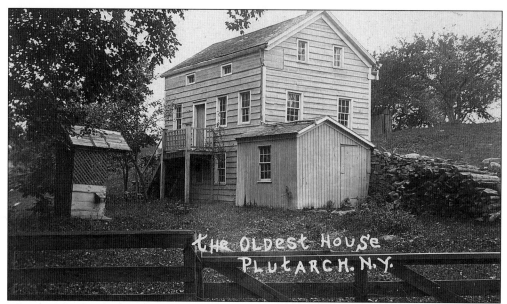

Christened "the oldest house in Plutarch," this property still stands on Van Nostrand Road. The well house has been moved and the house modified. The hamlet on the northeastern edge of town was originally called Gahow by a group of Pennsylvania farmers who settled there *c.* 1800. Later, it was known as Cold Spring Corners. The name Plutarch, for the Greek biographer, was adopted when a post office was established in 1886. (Courtesy of Vivian Wadlin.)

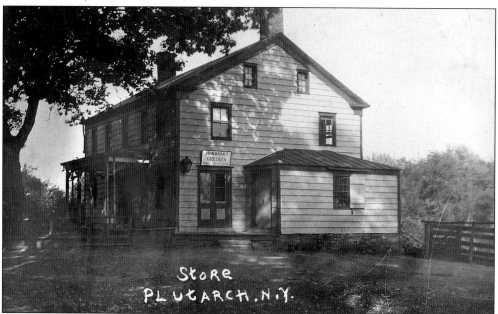

For many years, Plutarch had its own general store located at the crossroads in the heart of the hamlet. The store was stocked with everything from food and clothing to medicine and hardware. Postal services were also offered in 1886 and then again from 1890 to 1905. Some proprietors of the store were J.A. Burger, Nathan Van Wagenen, Thomas Cranshaw, Michael Raab, and Martin Wennerholm. (Courtesy of Vivian Wadlin.)

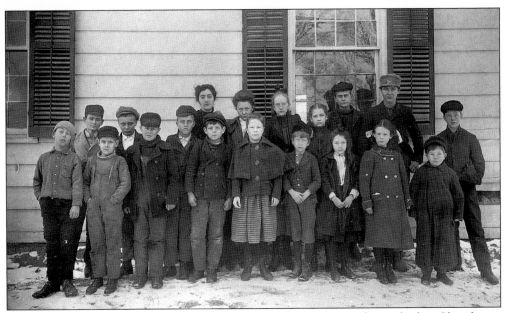

A young Sunday school class *c.* 1908 stands beside the Plutarch Methodist Church, on Hawley's Corners Road. The clapboard church, built during the Civil War, still has a congregation, one that has dwindled to just a handful in recent years. The church also has its original windows, handmade pews, kerosene lamps, old pipe organ, and stepping-stone out front to help women descend from their carriages.

Cousins Vivian and Michael Yess pose shyly in front of their century-old schoolhouse in 1949. The school custodian "Miss Emily" Finkenstadt can be seen in the background. Rural School District No. 5 in Plutarch had 100 children eligible to attend the one-room school in 1875, but an average daily attendance of only 31 students. (Courtesy of Vivian Yess Wadlin.)

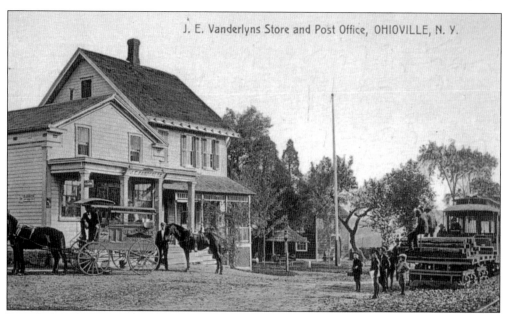

J. E. Vanderlyns Store and Post Office, OHIOVILLE, N. Y.

Long before the New Paltz-Highland trolley passed through the business section of Ohioville, which is still intact, the hamlet had its own post office, store, chapel, and schoolhouse. Freers, Hasbroucks, and Heatons built early homes in the area, originally called Helltown. When Moses Freer returned in 1850 from a stay in Ohio, he convinced the community to rename the hamlet Ohioville. Freer died of typhoid fever in 1873.

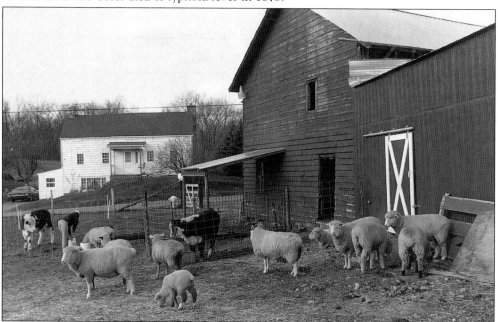

The 1850s vintage house and barns on North Ohioville Road create the illusion of an intact property. In fact, the house sold separately more than 15 years ago and is no longer part of the farm. However, the barns do support a working farm that specializes in raising Dorset sheep and Hereford beef cows. In 1845, area farms raised 6,469 sheep; 11,127 pounds of wool were marketed that year. (Courtesy of the *Herald*.)

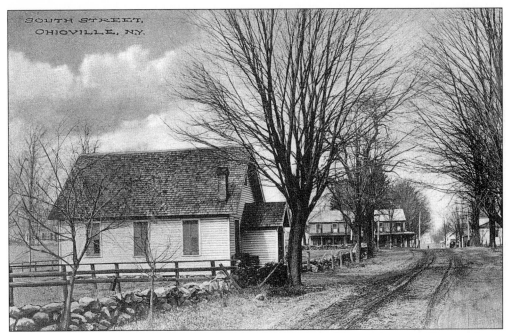

The Ohioville community built a chapel in 1898, adding the steeple some 30 years later. Although owned by the Reformed Dutch Church, the Ohioville Chapel soon became nonsectarian, as visiting Episcopalian and other ministers filled the pulpit. With the last service held in 1945, the building was sold in 1949. It was moved back south of Route 299 and remodeled into a private home. (Courtesy of Vivian Wadlin.)

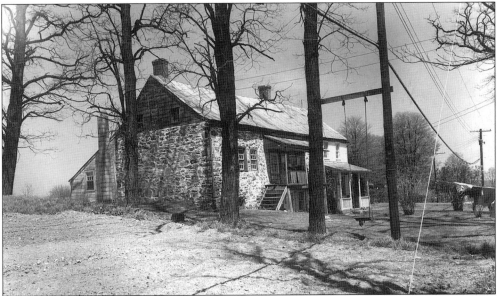

This house stands on the defunct New Paltz Turnpike, once the main thoroughfare to the Hudson River. Pedestrians used the road toll free, but other tolls varied from 3¢ to 12¢ for everything from a horse and buggy to a herd of pigs. This section of the turnpike, now called Paradies Lane for the longtime owners of the house, was dead-ended when the New York State Thruway came through in 1954. (Photograph by Erma DeWitt.)

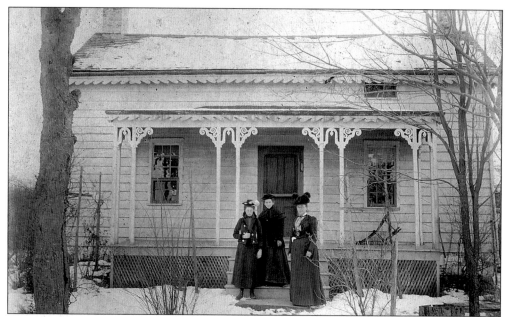

Nine families along the old turnpike on the outskirts of Ohioville lost their homes, barns, or outbuildings during Thruway construction and the rerouting of Route 299. The Louisa Minard house, pictured here, was demolished, and some of the other buildings were relocated. In just the Ohioville to Whiteport section of the Thruway, over 200 properties were affected by the construction. (Courtesy of Rosalie Nelson.)

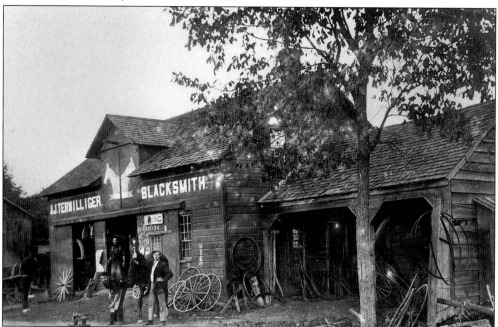

Alanson J. Terwilliger kept horses shod, repaired rickety buggies, and forged farm tools at his blacksmith shop located in Ohioville. Early records show that Moses Freer, the man who named Ohioville, began a similar business at the same location in 1836. Today, the College Diner on Route 299 East marks the spot shown in this *c.* 1908 photograph.

By the time Charles and Biaggi "Bessie" Ligotino came to New Paltz in 1923, half the children attending the Ohioville district school were of Sicilian heritage. Immigrants from Sicily had begun arriving in the area 30 years earlier, many initially hired as laborers on major construction projects. Others acquired fruit farms and ran boardinghouses. The Ligotinos operated a boardinghouse and fruit farm at 97 South Ohioville Road. (Courtesy of Elizabeth DuBois.)

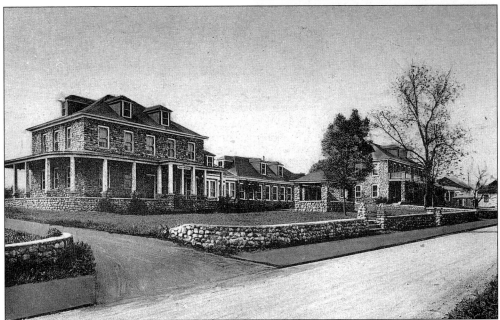

The Joseph Locascio family came here from New York City in 1913. In 1920, the Locascios entered the boardinghouse business. Villa Locascio became so popular and well known for Ann Locascio's excellent cooking that it soon expanded to include three cobblestone buildings, a swimming pool, tennis court, and dance hall. John Lipani bought the complex in 1946, changing the name to Villa Lipani. Currently owned by the Cusa family, it is called Villa Cusa.

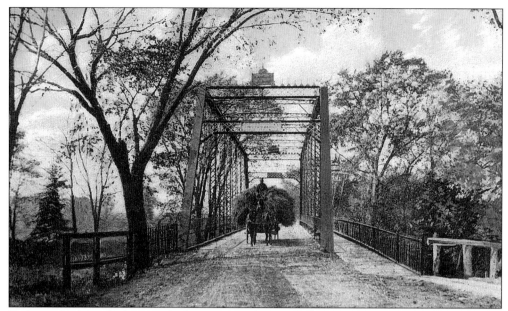

Built not far from the historic fording spot on the Wallkill River, the first iron bridge replaced a covered bridge erected in 1845. Settlements west of the Wallkill River predated both of these bridges. By the early 1800s, Hasbrouck, Freer, and Steen families had established homesteads about two miles directly west of the village. They began to clear and cultivate the land on the upland meadows of the Shawangunks.

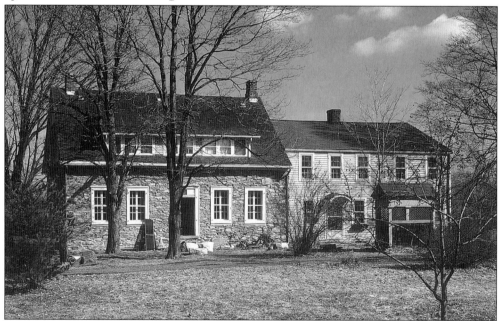

The frame section of this house was detached and moved a few hundred yards north, where it now stands as part of a separate property. In 1797, David Hasbrouck began building the stone section "at Olynute near the Mountain" (from the Dutch name for butternut tree). The hamlet soon became known as Butterville. So many Quaker families eventually moved to the area that it was often called the Quaker neighborhood.

David Hasbrouck constructed this barn only after completing his stone house. The smaller part of this unique Dutch barn on Butterville Road was taken down in the 1980s when the larger section was converted into a greenhouse. Hasbrouck's Quaker neighbor Zephaniah Birdsall also had a Dutch barn in the area "at Olynutekill," now the Humpo Kill. That 45-foot-square structure, built before 1797, no longer exists. (Photograph by Marion Ryan.)

Now landlocked by private property, a Quaker cemetery known as the Friend's Ground is located directly behind the three-story house. Minard, Mullenix, Sutton, and Wakeman families are buried there. A Quaker meetinghouse, built c. 1820 and since demolished, stood nearby. This Mountain Rest Road intersection connects Butterville Road on the left with Canaan Road on the right. (Photograph by Marion Ryan.)

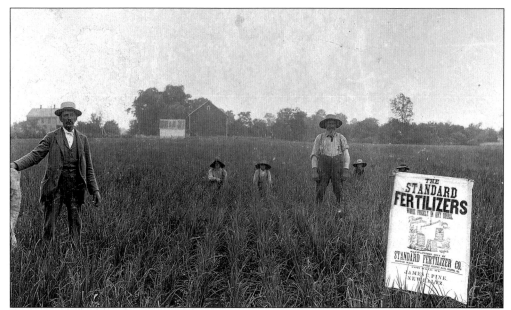

Farmers in an unidentified field seem to be advertising fertilizer sold by James C. Pine. In 1854, the 100-acre Butterville farm owned by James C. Pine's father harvested 270 bushels of grain, including corn and oats, rye and winter wheat. Nearly half of the farm was in pasture; 13 sheep, 10 swine, five cows, two oxen, and two horses grazed the fields. The farm also produced apples, cider, and 12 pounds of maple sugar. (Courtesy of Vivian Wadlin.)

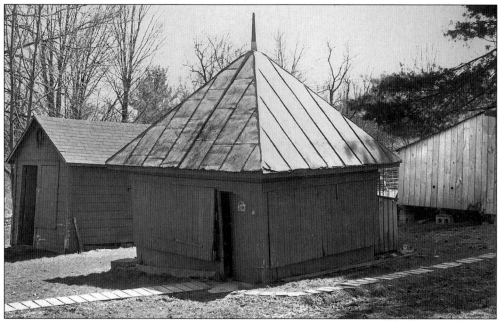

For 16 years, judges sat in an elevated stand calling finishes at Brodhead Driving Park, a half-mile racetrack complex located west of Springtown Road near Mountain Rest Road. When the popular but controversial enterprise failed in 1904, the buildings were dismantled and hauled away. This pointed-roof structure, once the top half of the judges' stand, is now a storage shed on a small farm nearby. (Photograph by Lauren Thomas.)

Methodist minister Charles Edward Hewitt published two novels set in and around New Paltz. He knew the area well, having established Beulah Land on Mountain Rest Road in 1900. Hewitt was known for playing pranks at church picnics. He and his wife ran the summer camp for needy city boys. About a dozen boys would arrive in two-week relays all summer long. The cabin was later remodeled and is now a private home. (Courtesy of Mimi McGloughlin.)

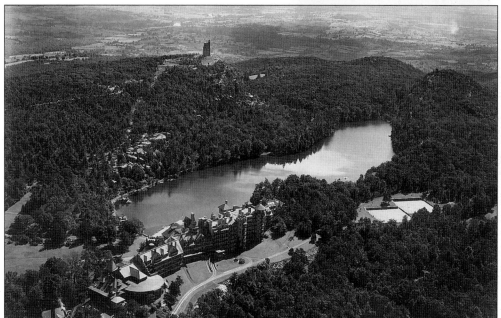

Albert and Alfred Smiley bought John Stokes's tavern, lake, and 273 acres in the Shawangunks for $28,000. Opened in June 1870, Lake Mohonk advertised locally: "Orderly, well-disposed parties, who wish to use the grounds for pic-nic purposes, are still at liberty to do so, except on Sundays." Thus began the saga of the Quaker-owned Mohonk Mountain House resort, seen here in 1928, which is still operated by the Smiley family today. (Courtesy of Mohonk Mountain House Archives.)

Janet Jarvis visits her Aunt Esther *c.* 1950, on "Million Dollar Farm," so called for its state-of-the-art dairy barn, pictured here. Dairy farming was always the leading industry in the Springtown hamlet. For a brief period in the early 1800s, the hamlet rivaled New Paltz as a business center. A thoroughfare and stage line from Kingston passed through, heading south. Early taverns thrived along the route. (Courtesy of Esther Ott.)

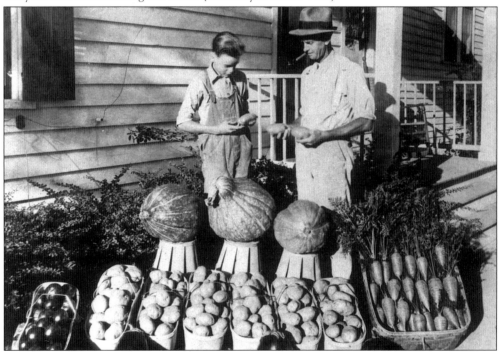

In 1927, Jesse Deyo and son Donald of Springtown display produce harvested from their fertile fields bordering the Wallkill River. By the early 1900s, the hamlet was a thriving community with its own train depot, post office, schoolhouse, and chapel. Tourists from New York City returned to their favorite boardinghouses year after year, drawn back by bounteous home-cooked meals, country recreation, and general camaraderie.

Riverview Cottage boarders played lawn tennis, swam in the Wallkill, and went on many excursions. Proprietor Mrs. George MacMurdy writes to a friend in August 1907, "Are you through haying? Ours is all in. House full. No time left for self." She goes on to outline a week spent entertaining boarders. Teams of horses took daily mountain trips to Mohonk, Minnewaska, and waterfalls, with a hayride on Saturday and church on Sunday.

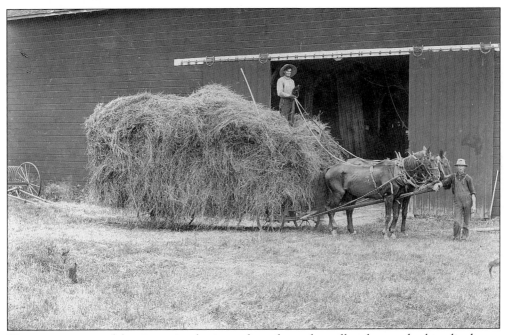

Haying was serious labor-intensive business throughout the valley, but as the boardinghouse business prospered, hay wagons were often co-opted for a more frivolous use. Vacationers hopped aboard the wagons on beds of hay or straw. They were treated to leisurely rides through the countryside. Singing and cuddling, especially on nighttime hayrides, added to the enjoyment. (Courtesy of Brad Burchell.)

Irving Kauder established a showplace poultry-breeding business on Springtown Road in the 1930s. His pedigreed leghorn hens, with names such as Kauder's Century Belle and Hen of the Century, held U.S. and world laying records for all breeds. He kept meticulous pedigree and production charts as he sought to improve the breed. (Pen and ink drawing by Cami Fischer, based on *a c.* 1939 aerial photograph of the Kauder farm.)

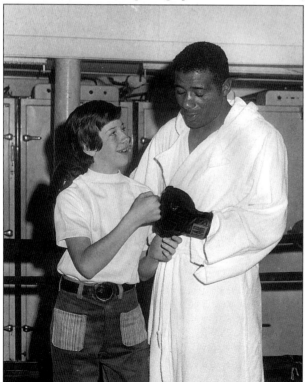

"An Evening with Floyd Patterson; a Gift to His Friend" was a spectacular boxing exhibition and show held at the Elting Gym on the night of May 12, 1972. Floyd Patterson, the present resident of the above farm, staged the event to raise money for 12-year-old David Ingraham. Over 3,000 people attended the benefit for the boy, who had just lost his leg to bone cancer. (Photograph by John Kruh, courtesy of Bud Ingraham.)

Two

GAINING AN EDUCATION

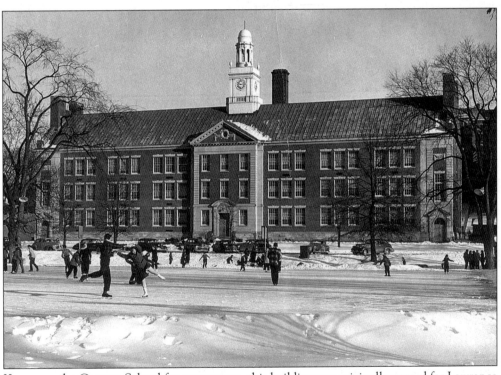

Known as the Campus School for many years, this building was originally named for Lawrence H. van den Berg who had been the Normal School's fifth principal for nearly two decades. Gov. Franklin Delano Roosevelt attended the groundbreaking ceremony in 1930 for the van den Berg School of Practice. From 1932 to 1982, the elementary school served as a center for research in the development and evaluation of educational theories and practice. Until 1953, all New Paltz elementary students, except for those attending district and parochial schools, were educated here. College students preparing for careers in education observed, participated, and did their student teaching in these classrooms. The landmark clock tower was destroyed by fire in May 1990. (Photograph by Neil Croom.)

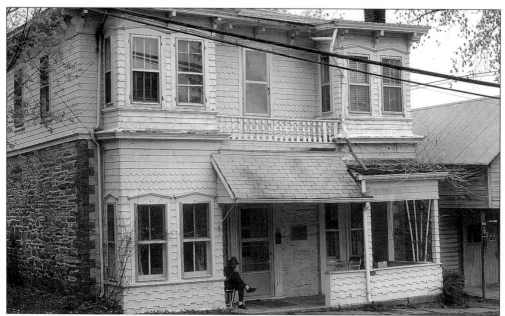

Erected in 1812, this building at 15 North Front Street served as the first public, or common, school until 1874. Stones set aside 39 years earlier for the specific purpose of building a schoolhouse were finally used to construct the first floor. The building has also been a blacksmith shop, a private residence, and recently, a commercial space. Longtime resident Nicholas Manolakes sits on his front porch in this 1984 photograph.

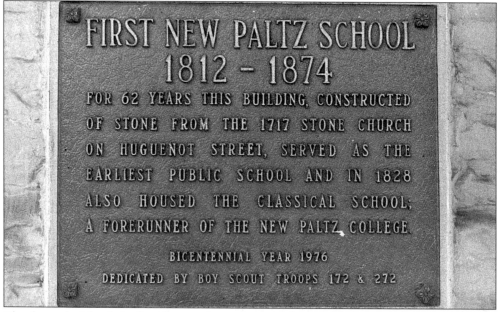

Thanks to the New Paltz Boy Scouts, this permanent plaque with its brief schoolhouse history helps give distinction to the building at 15 North Front Street that might otherwise be overlooked. Public school students attended classes on the first floor, and the Classical School mentioned on the plaque occupied the upper floor. Tuition at $25 a year included course work in Latin and Greek. (Photograph by Lauren Thomas.)

Responding to overcrowded conditions in the public school, Rebeckah Elting (1791–1869) bought land just north of the Reformed Church and had a school building constructed. The Select School operated there from 1840 until 1853. "Aunt Beccie" was known for her old-fashioned good sense and benevolence. Although she owned the 1799 Brick House next to the old burial ground, she lived most of her life on the Locust Tree farm. (Courtesy of John and Katia Jacobs.)

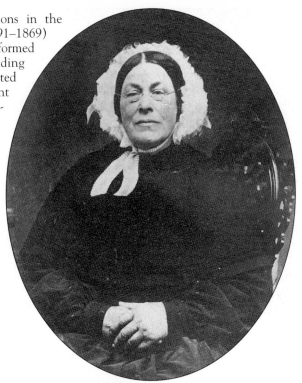

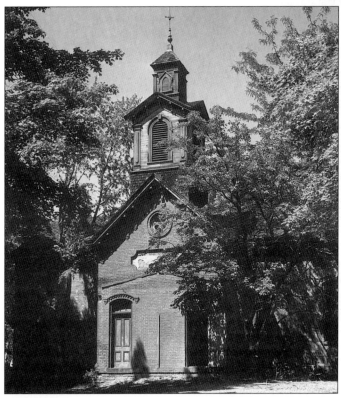

Built in 1874 to replace the first public schoolhouse, this larger red brick building served as the village school for only 15 years. In 1901 and 1902, it functioned as a recreation hall and classroom for 70 Cuban teachers enrolled at the Normal School. Called the Cuban Annex, the building was later made available to the public for club meetings. It was completely abandoned after World War I. (Photograph by Erma DeWitt.)

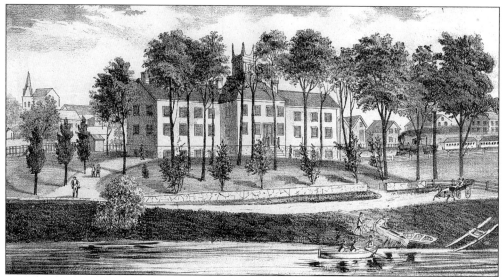

As interest in classical studies swept across the state, townspeople began collecting money for a suitable building. Constructed in 1833, the Academy was soon enlarged by the addition of long wings to the north and south. The graphic drawing shows the Wallkill Valley Railroad passing behind the school. This new form of transportation arrived in 1870, enabling students from neighboring towns to attend classes on a daily basis. (From the 1875 *County Atlas of Ulster*.)

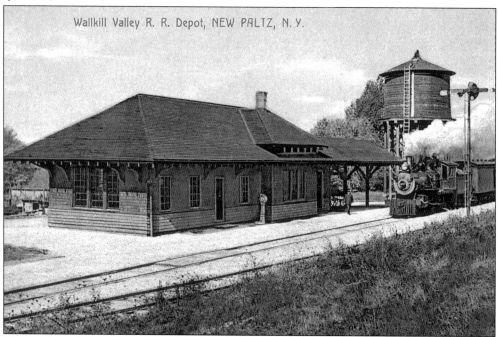

Wallkill Valley R. R. Depot, NEW PALTZ, N.Y.

The Wallkill Valley Railroad was Ulster County's first railway. Construction workers along the 33-mile-long line between Montgomery and Kingston were predominantly young Irish immigrants, working 10 hours a day for $1.75. After a bumpy start, passenger and freight service improved as the proposed connections to Albany and New York City were realized. By 1885, four daily passenger trains made stops in New Paltz. Regular passenger service ended in 1937.

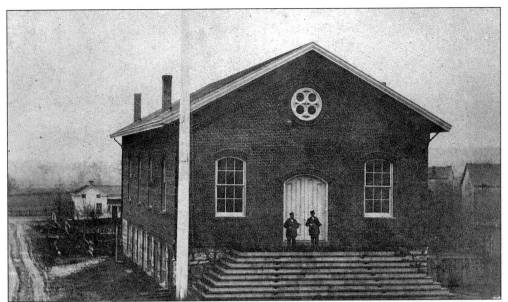

This beautifully designed North Chestnut Street building, erected in 1863 by the New Paltz Literary Association, brought together students and community members. Variously called the Village Hall, the Opera House, St. Joseph's Hall, and the Academy Theater, the spacious upstairs auditorium accommodated popular lecture series, theatrical productions, political rallies, church services, and dances. The basement has been used for temporary classrooms and residential apartments, and has housed various eating places.

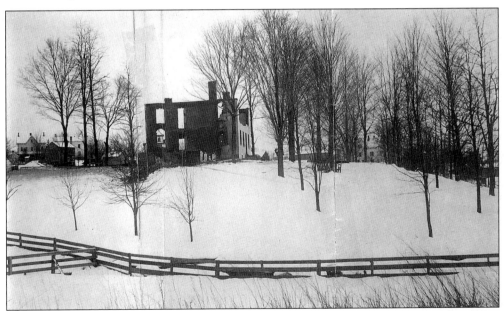

The Academy offered two- and three-year programs that qualified graduates to teach in New York State elementary and secondary schools. Local high school students were also educated in this building. On February 28, 1884, a fire broke out in the principal's office. The entire building was destroyed. Trustees quickly rebuilt the Academy but soon negotiated successfully with Albany for Normal School status.

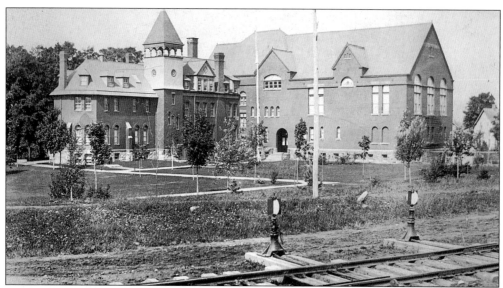

In May 1885, Albany passed a bill providing for "the location of a Normal and Training school with an academic department, in the village of New Paltz." By 1891, a large four-story brick addition gave the school an imposing appearance on the banks of the Wallkill River. All Normal School principals, Eugene Bouton, Frank Capen, Myron Scudder, John Bliss, and Lawrence van den Berg, have buildings on the SUNY campus named for them. (Courtesy of Ruth Hirsch.)

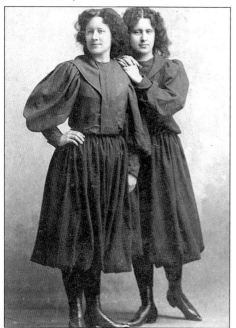 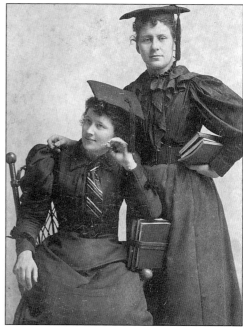

Normal School women were expected to wear dress appropriate for exercises when gathering in the large gymnasium: either a gymnastic suit or an ordinary dress with a blouse waist. Material and color were left up to the individual, but dark blue flannel was recommended, as were shoes without heels. Mary Alice Niver (on the right in both photographs) and a friend model their gym suits (left) and pose for their June 1897 graduation (right). (Photographs by H.L. Schultz.)

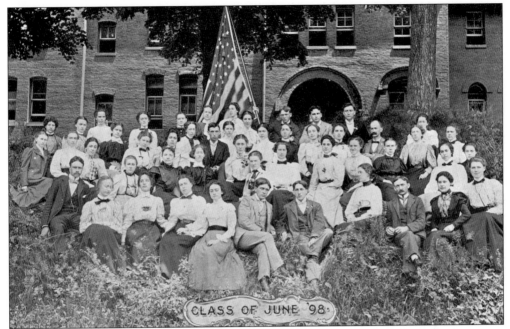

Sitting on the hill in front of their future alma mater, graduates in the Class of 1898 pose for their senior picture. By this time, 637 students from 30 counties were attending the Normal School. The average age of the student body had risen from 19 years old to 20½.years old. (From the June 1898 *Normal Review.*)

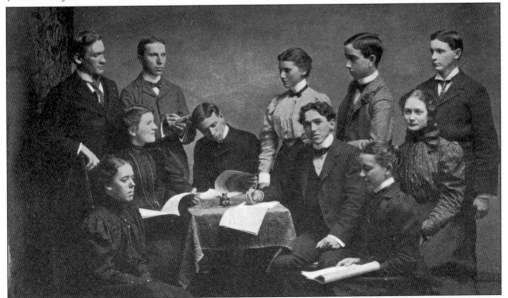

Alfred Harcourt (1881–1954) had a childhood that included farm chores and his beloved books. President of his 1900 Normal School class, he poses (standing, second from right) with editors of the *Normal Review*. Harcourt founded the hugely successful Harcourt, Brace and Company publishing house in 1919. He never lived in New Paltz as an adult but often visited to drive through blossoming apple orchards or up into the Shawangunks. He is buried in the Elting Ground on Huguenot Street. (From the November 1898 *Normal Review.*)

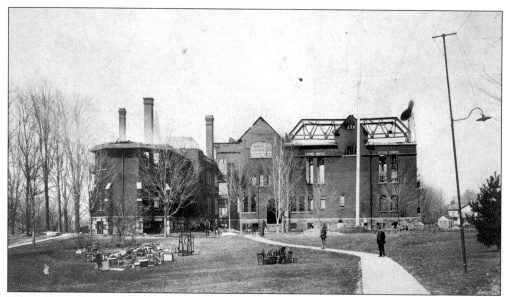

When Normal School students returned from Easter vacation in 1906, they discovered the gutted remains of their school. The fire had been started accidentally by workers making repairs in the attic. Principal Scudder's lightning fast response to the tragedy soon had students trekking all over town to temporary classrooms. The Casino at 91 Main Street became the gymnasium. Rush orders placed by telegraph, telephone, even special couriers, resulted in new desks, maps, and books arriving within days.

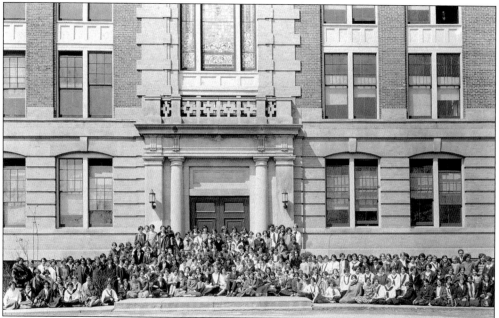

"Never in the entire history of Ulster County had there been gathered together so distinguished a body of men to attend any public function as assembled in May 1907 to witness the ground breaking for the new Normal School . . ." reported the regional press. "Old Main" has long stood as a symbol for education in New Paltz. For years, the student body included teachers in training, shown here in 1926, as well as local primary and secondary students.

42

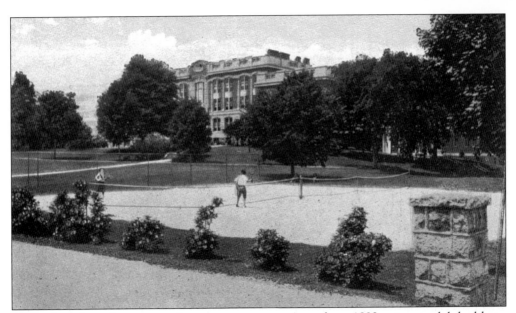

Tennis has always been a popular sport on campus. As early as 1892, a tennis club had been organized. In the spring of 1909, the tennis courts pictured here were completed. Beginning in 1955, the Hudson River Tennis tournament was held annually on six clay courts, located on the expanding campus. Pres. William Haggerty's love of the sport encouraged the building of at least 25 more courts. (Courtesy of Tor Shekerjian.)

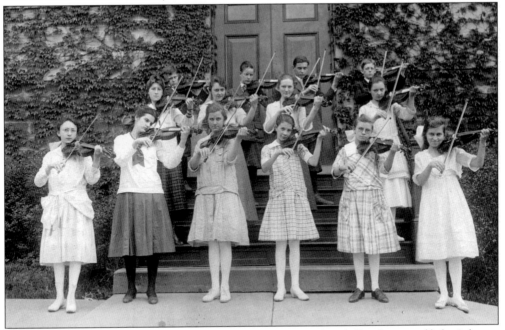

Helena Gerow (middle row, second from left) moved from Plattekill to her grandfather's house on Southside Avenue to attend high school in New Paltz. She joins other young violinists c. 1912 on the northern steps of Old Main. This location was swallowed up by the college auditorium addition in 1920. After major renovations in 1993, the 1,200-seat auditorium was renamed Studley Theater for its benefactor. (Photograph by H.L. Schultz.)

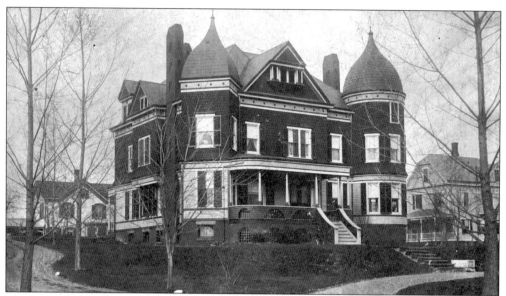

New York State bought this extravagant Victorian house in 1899. Known as Hayden's Folly, the house on the corner of Main and Prospect had been under construction for six years. Soaring construction costs forced James Hayden into foreclosure proceedings long before it became livable. The house, which served as the gracious residence for three Normal School principals, was destroyed by fire in 1991.

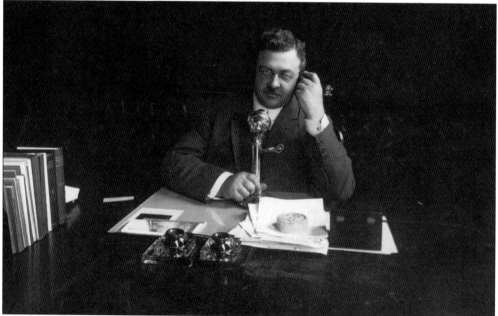

Rules, regulations, efficient management, and landscape gardening characterized the 28-year tenure of Dr. John Carleton Bliss, the third Normal School principal. From 1908 to 1923, he watched over his students, especially the young women, monitoring their every move. He dictated dress codes, kept track of all off-campus excursions, and checked food preparation in village boardinghouses. He insisted on keeping his own personal attendance records for over 20 years. (Photograph by H.L. Schultz.)

Arthur Bruce Bennett (1882–1961) reveals something of his theatrical flair in this 1947 portrait. He was the English college professor remembered for 40 years of dramatic literary interpretations, the community theater director prone to casting himself in highly disguised costumed roles, the avid trout fisherman who could spin fish tales with the best of them. As an imaginative speaker, he was in great demand throughout the community. (Photograph by Erma DeWitt.)

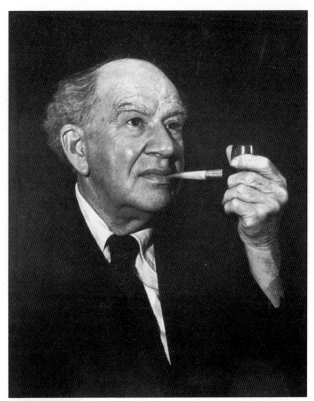

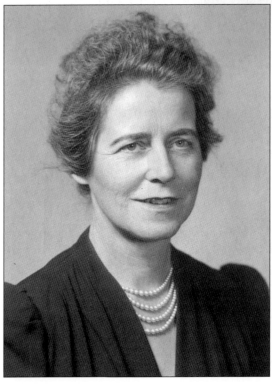

Rebecca McKenna (1888–1967), faculty member of the State Teachers College from 1931 to 1952, taught English, children's literature, and dramatics. She succeeded Bruce Bennett as the director of the Dramatic Club, later known as the New Paltz Players. The Rebecca McKenna Theater on the SUNY campus is named in her honor. (Courtesy of Alfred Marks.)

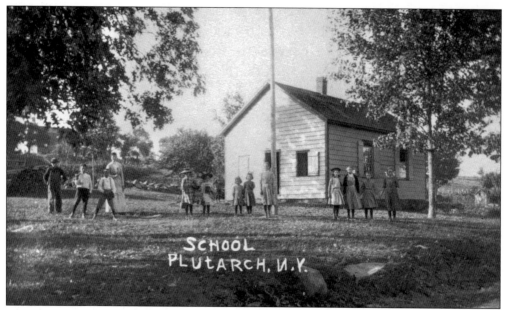

Closed in 1956, this rural schoolhouse served the Plutarch neighborhood for 107 years. It is now the home of the Plutarch Sportmen's Club. The centralization of school districts across the state slowly ended one-room schooling. Most of the seven familiar looking structures that were built in the town of New Paltz survive today as residential dwellings.

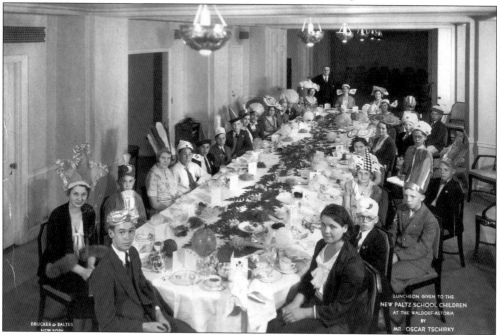

June Chambers's sixth-grade classmates never forgot the festive luncheon party at the Waldorf-Astoria Hotel given in her honor by her grandfather Oscar Tschirky. Known as "Oscar of the Waldorf," the maitre d'hotel is credited with many culinary delights, such as Thousand Island Dressing, Waldorf salad, and Veal Oscar. His country home in New Paltz became the Culinarian Home Adult Care Center. (Courtesy of Sue Stegen.)

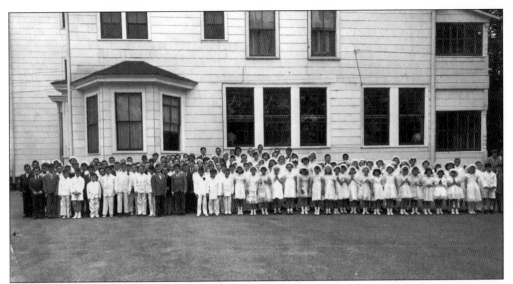

The children of St. Joseph's Parochial School are dressed to receive confirmation during a rare parish visit by the bishop. The school first opened on September 12, 1949, with 110 students enrolled. Taught for 20 years by both lay teachers and sisters of the Order of St. Benedict, the financially burdened school was forced to close in June 1969, as fewer women entered the Benedictine Order. (Courtesy of Elizabeth DuBois.)

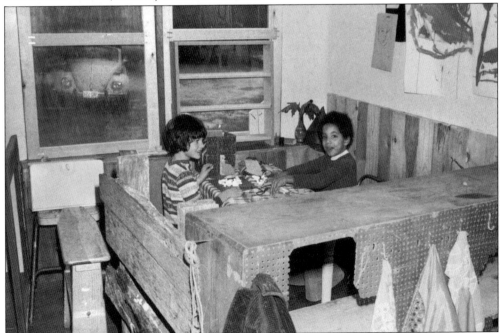

Josh Molay and Ceci Marquette tackle a creative construction project in a cozy cubby at the Unison Learning Center's Friends of the Mountain School. A dozen children attended this alternative school in 1976 and 1977. The school closed after two years; Unison Learning Center continues as a vital arts, learning, and performance center. Other area alternative schools included High Meadow in the 1980s and Sunwise, currently located on Plains Road. (Courtesy of Stuart Bigley.)

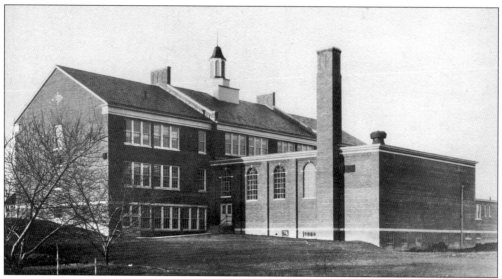

Opened in 1931 after a local referendum consolidated 12 small districts into a centralized school, this building gave New Paltz high school students their first chance to shine. No longer dominated by older Normal School students, they published their first yearbook, *The Huguenot*, in 1932. This photograph of the building, currently known as the Middle School, predates major additions. In 1956, a large elementary wing and separate gymnasium were added to the southern and eastern sides of the structure. (Courtesy of William and Sally Rhoads.)

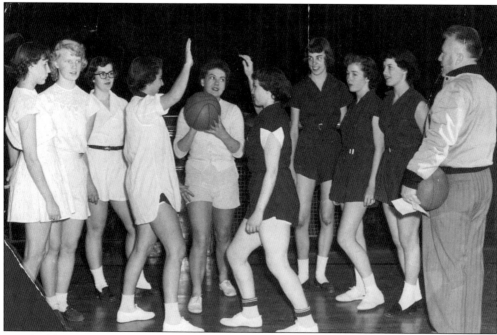

Coached by Larry Johnson, this 1952 team defeated both Wallkill and Kerhonkson twice to go undefeated in its four-game season. Demonstrating skills they will use in their next varsity basketball game are, from left to right, Lillian Osterhoudt, Mary Jo Ahlberg, Dorothy Rasmussen, Denise Burke, Dona Beattie, Phyllis Klyne, Barbara Misner, Altrude Palmer, and Theresa Power.

Once the private home of Mr. and Mrs. Stanley Hasbrouck, this building became school property in 1953. Helen Coutant and Marjorie Glenn taught kindergarten and first grade here for three years. Later, the district bought the adjacent Anton Hug residence on Manheim Boulevard and joined the two structures. Currently, the New Paltz Central School District uses the 196 Main Street address for its administrative offices.

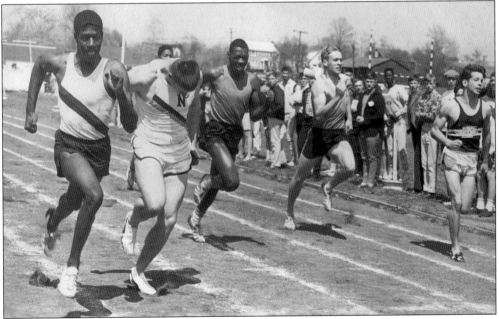

Sprinting for the finish line in the Invitation 100-Yard Dash, eight of the area's fastest schoolboy runners compete for a special trophy at the Hudson Valley Relays. For 18 years, beginning in 1951, the huge meet brought together over 1,000 track and field athletes from 100 schools within a 75-mile radius of New Paltz. The event was held at what is now the Middle School track. (Photograph by John Kruh.)

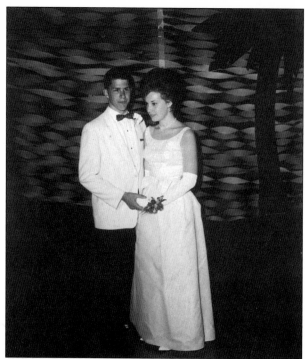

Albert "Duke" Bickmore and Donna Johnson pose at their junior prom in the spring of 1964. Using crepe paper and other decorative materials, juniors spent countless hours transforming the gymnasium into an "enchanted island" complete with palm trees. Junior proms were held in the Middle School gym until the Class of 1972 staged its prom at the Ski Minne restaurant. (Courtesy of Donna Ziegler.)

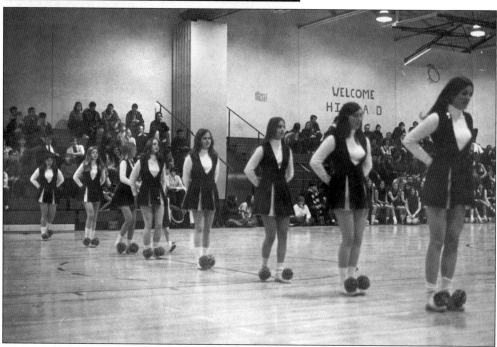

Cheerleaders identified from left to right as Marian Finkelstein, Susan Barry, Ann Baker, Patty Steffens, Joyce Denton, Patty Terranova, Joan Donahue, and Jackie Dieterich get ready for their next cheer in front of hometown fans in the new high school gym. The present high school, located on South Putt Corners Road, opened in 1968. It included a large library, a 700-seat auditorium, 25 classrooms, and this 1,200-seat gymnasium.

Duzine Elementary School opened its doors to students, grades kindergarten through sixth, in September 1963. The word *Duzine* is a word that has been used to describe an early form of government in New Paltz. Robert Bassik (right) was hired as principal one month after the school opened and held that position until he retired in 1988. Duzine was the primary elementary school in the district until Lenape Elementary was opened in 1992. Specifically, *Lenape* means "original people." The Esopus Indians of New Paltz were of the Lenni Lenape, or Delaware Nation.

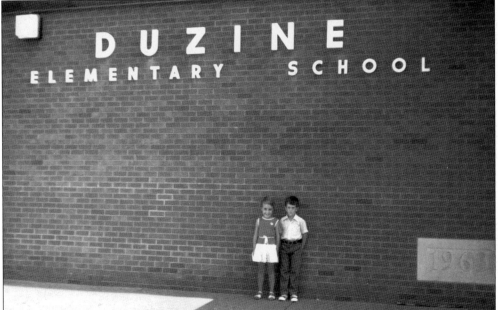

Jeanette Unger and Giorgios Vlamis await the beginning of their first day of kindergarten in this September 1983 photograph. Twelve years later, Jeanette and Giorgios graduated as valedictorian and salutatorian of the New Paltz High School Class of 1996. (Courtesy of Trudy Unger.)

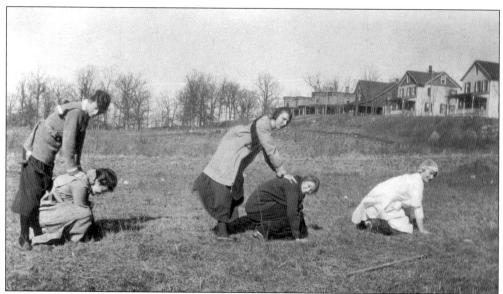

Pledged to Arethusa in 1917, five sorority sisters play leapfrog in an unkempt field below the Arethusa Sorority House, at 11 North Oakwood Terrace. Fraternities and sororities played an important part in the lives of many New Paltz college students. These Greek organizations provided housing for their members and sponsored a wide range of social activities both on and off campus. (Courtesy of Dennis O'Keefe.)

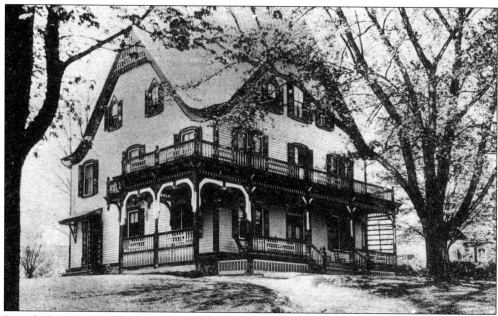

Long before it was the St. Joseph's Parochial School, the building at 16 South Chestnut Street was the home of Elsie Hasbrouck. Built in 1888, it was the largest private residence in New Paltz. Elsie Hasbrouck's son, Daniel A. Hasbrouck Jr., inherited the house in 1915. He named it Shady Knoll and took in boarders. He is remembered for inaugurating the village water system and selling it to the village in 1913.

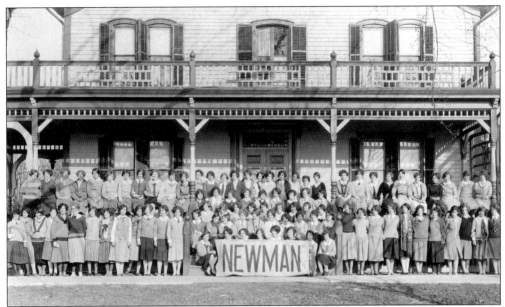

The Catholic Church purchased Shady Knoll in 1925. It became the home to Catholic women attending the Normal School. Like many Catholic student centers across the country, the house was called Newman Hall after John Henry Cardinal Newman. An 18-room addition to house the young women was added in 1930. Three years later, the name was changed, once again, to the Artemis Sorority House.

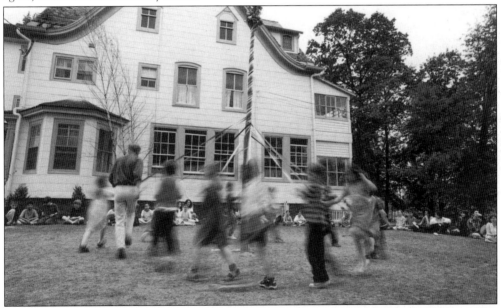

Dancing around the maypole is an annual rite of spring for these school children. The Mountain Laurel Waldorf School, named for an indigenous flowering bush, was chartered in 1983. The school began as a single kindergarten-preschool class held first at 12 North Oakwood Terrace. The school was later located at the corner of Route 32 North and Rocky Hill Road from 1985 to 1995 before moving to its present 16 South Chestnut Street location. (Courtesy of Mountain Laurel School.)

The house at 244 Main Street looked ordinary, but in fact, an extraordinary social experiment in communal living was in progress at this address during the early 1900s. Schoolteacher Kittie Gage and her friend Miss Hobbie invited Normal School friends, both male and female, to be a part of their extended "family." Naming the house the Wigwam, they proceeded to decorate it with Indian relics from their travels. The house was razed in 1964.

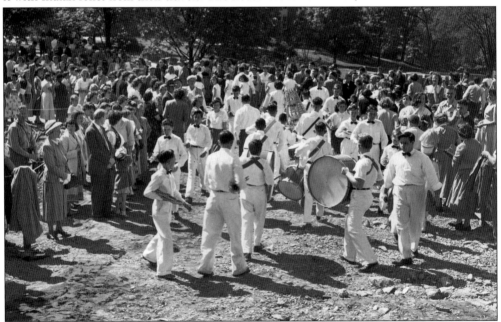

Members of the New Paltz American Legion Junior Drum and Bugle Corps scramble to complete a tight maneuver as spectators press forward. The 1950 cornerstone-laying ceremony for the original Student Union Building drew a large, enthusiastic crowd. The Drum and Bugle Corps was sponsored by the Sullivan-Shafer Post No. 176, named in honor of Dennis Sullivan and Raymond Shafer, both killed in action during World War I. (Courtesy of Alfred Marks.)

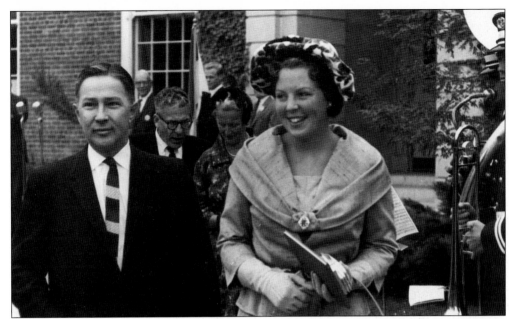

In September 1959, Crown Princess Beatrix of the Netherlands toured the Hudson Valley for the 350th anniversary of Henry Hudson's voyage up the Hudson River. The woman who would become queen visited New Paltz, where nearly 4,000 people attended a ceremony in front of the old college library. While the high school band played, Dr. William Haggerty escorted her to the platform past an honor guard of Boy and Girl Scouts. (Courtesy of Alfred Marks.)

Eleanor and Franklin Delano Roosevelt visited New Paltz many times. In July 1955, New Paltz College Dean John Jacobson invited Eleanor Roosevelt, then in her 70th year, to speak at a retired teacher's workshop. The title of her speech that day was "Staying Young and Healthy." (Courtesy of Alfred Marks.)

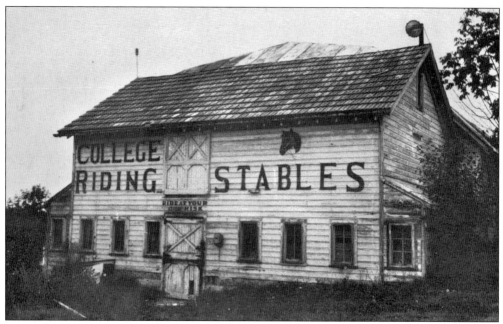

Located near the present College Terrace Restaurant, the college-sponsored riding stable was managed by Alfred Manganaro in the 1950s. College students, pupils from the Campus School, and community residents could ride for $1.50 an hour or purchase a $10 ticket good for 10 hours. Riding lessons, group hayrides, and sleigh rides were also available. Construction of the Elting Gymnasium's parking lot resulted in the demolition of the abandoned stable. (From the 1966 *Paltzonian*.)

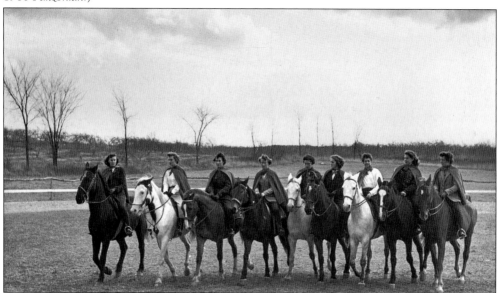

New Paltz Riding Club members appear to be practicing for an upcoming horse show in this photograph. Before World War II, the club held annual horse shows on the Flats along the Wallkill River. When the shows were revived after the war, they took place at the College Riding Ring. Jay LeFevre Jr. was ringmaster for the 1948 show, which attracted more 600 spectators from the area.

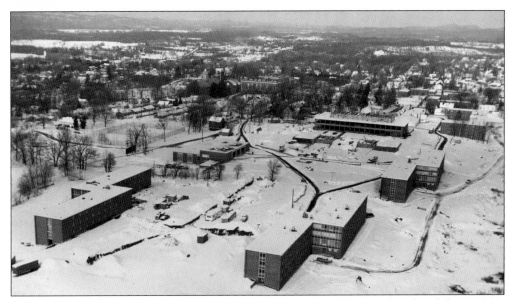

Gov. Nelson Rockefeller said that at no state university is the "magnitude of the massive [construction] program" more in evidence than at New Paltz. This 1962 aerial photograph shows four dormitories, Parker Dining Hall, and the Smiley Art Building in various stages of construction. Soon after this picture was taken, construction began on Elting Gym, Gage Hall, Sojourner Truth Library, the infirmary, humanities and science buildings, faculty tower, and the lecture center. (Courtesy of Alfred Marks.)

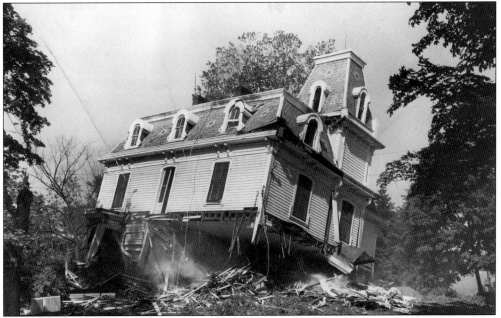

Relentless construction literally ripped apart neighborhoods on the south side of the village. Houses on Plattekill, Mohonk, Tricor, Fairview, Southside, and Excelsior Avenues were either moved to new locations or torn down. Homes on Route 208 and South Manheim Boulevard were also affected. This beautiful Victorian house on a section of Mohonk Avenue that no longer exists was razed to make room for the Wooster Science Building.

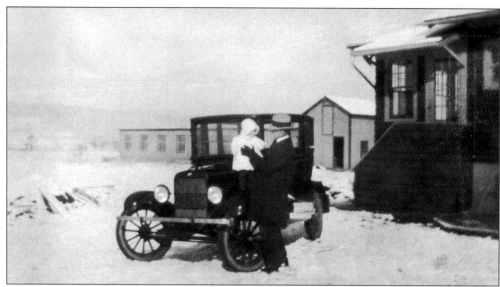

Four decades after George Willard Jenkins built his home and chicken farm out in the country on Modena Road (now Route 32 South), the expanding State University of New York claimed the property. The house was moved about two miles west to Brookside Avenue. Elsie DuBois Jenkins photographed her husband, their baby daughter Marie, and the car on the new farm in late October 1925, just three weeks after the family had moved in. (Courtesy of Marie Wiersum.)

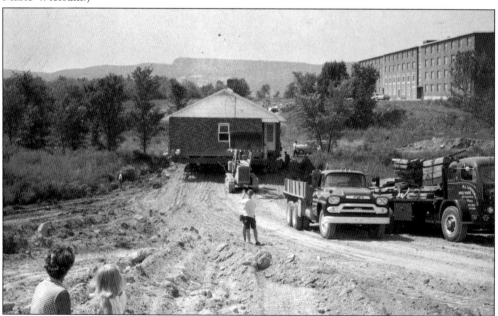

The George Mackey residence was one of five brick houses moved in 1964 from the east side of Fairview Avenue to present locations on Howard Street and College Avenue. Loop Road was specifically built in order to transport these houses across the campus. Forced to wait until Central Hudson removed electrical wires on Route 32 South, members of the Mackey family spent a memorable weekend living in their house while it was on the move. (Courtesy of George Mackey.)

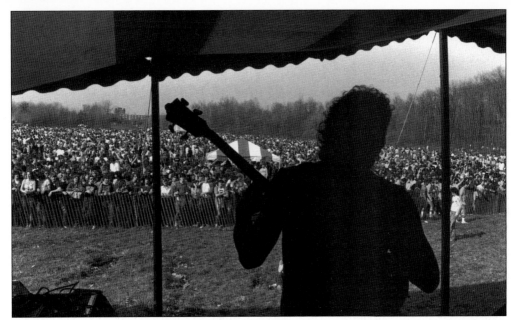

One of the biggest concerts ever held at the college was part of Spring Weekend 1970. Thousands of concertgoers flocked to the "tripping fields" on the southern edge of campus to hear the Youngbloods, Jefferson Airplane, and Joe Cocker. For those who missed this heady triple billing, other performers appearing in the 1970s included the Beach Boys, Jerry Garcia, Jethro Tull, Chuck Berry, and the Who. (Courtesy of the *Herald*.)

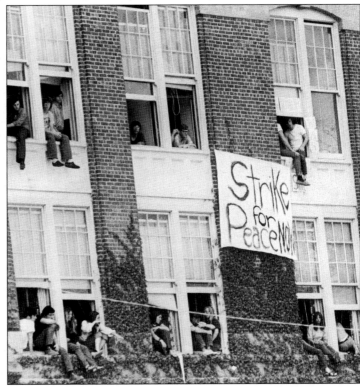

Anti-Vietnam War demonstrations escalated across the country following the National Guard confrontation on the Kent State University campus, which resulted in the deaths of four students. Student protesters shown here in May 1970 have occupied Old Main; similar protests took place at over 500 college administration buildings nationwide. Classes on the New Paltz campus were suspended for five days while negotiations between the students and the administration took place. (From the 1970–1971 *Paltzonian*.)

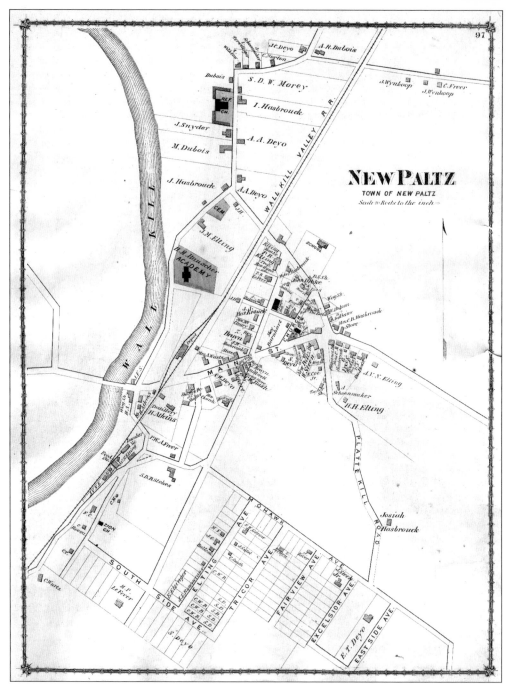

This map of the village of New Paltz highlights the locations of the New Paltz Academy and the Reformed church, on Huguenot Street. The map also identifies many residential and commercial properties within the village. (From the *County Atlas of Ulster, New York*, 1875.)

Three
LIFE ON MAIN STREET

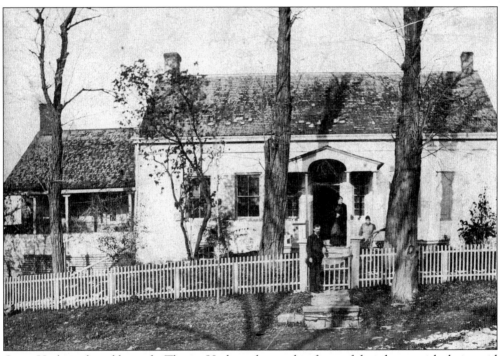

Oscar Hasbrouck and his wife, Theora Hasbrouck, stand in front of their home with their maid c. 1890. Although recognized as the oldest structure on Main Street, the exact dates for the composite frame and stone structure have never been established. Three generations of the Josia Elting family owned the land and homestead from c. 1750 to 1855. Although the Hasbroucks then held title for 65 years, it was always referred to as "the old Elting house." Part-time resident Philip Elting of Chicago bought the house in 1920 and presented it to the community "as a public library to be known as Elting Memorial Library." A formal dedication took place on October 16, 1920. Even though two modern additions to the rear of the building have more than tripled floor space, the view of the library from Main Street remains much the same as in this early photograph.

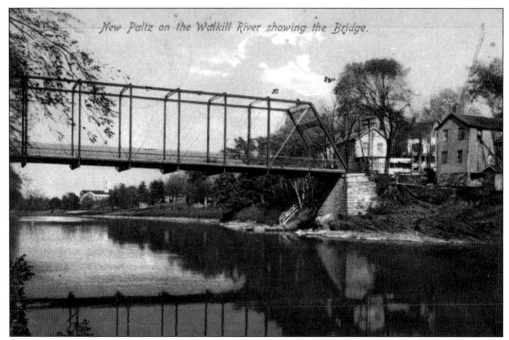

New Paltz on the Walkill River showing the Bridge.

Rising in Sussex County, New Jersey, the Wallkill River flows north through New Paltz on its way to the Hudson. This narrow iron bridge at the bottom of Main Street spanned the river for 50 years. Built in 1891 at a cost of $677, it was 153 feet long, but only 18 feet wide. Vestiges of its crumbling abutments can be seen just south of the present bridge.

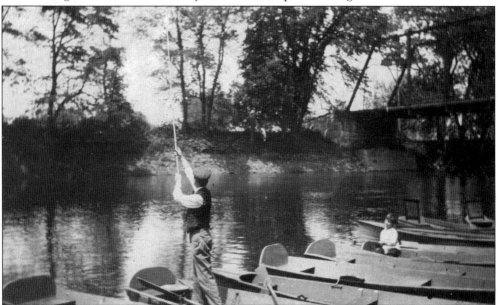

Wallkill River fisherman tended to brag in the local newspapers. One day in April 1896, John Bleecker caught 27 suckers and a carp weighing seven-and-a-half pounds. A five-pound eel was also caught that summer. Levi Williams reeled in a 22-inch-long black bass that weighed five-and-a-half pounds on July 4, 1906. The fisherman in this 1917 photograph casts his line into the river, just south of the bridge.

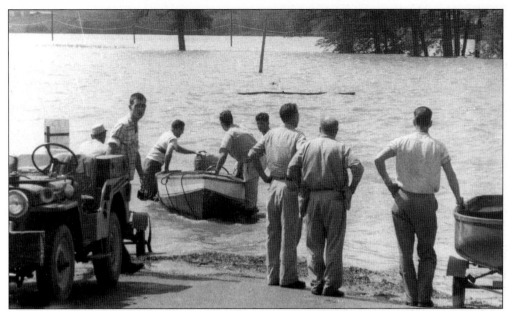

Residents still talk about the 1955 Wallkill River flood with awe. Nevertheless, other floods in other years were also dangerous and destructive. One night in 1898, three-year-old Ruth Hasbrouck and her parents fell from an upset wagon into icy February floodwaters on the flats. Her parents found Ruth caught by her clothing on a wire fence. The Maurice Hasbrouck family survived, but the horse and wagon were swept away.

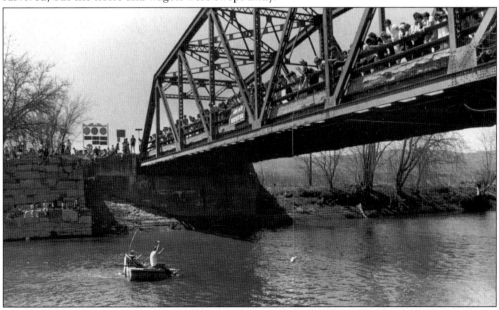

The present bridge over the Wallkill marks the regatta's finish line. Not so much a race as a spoof on racing, the goal was to make it to the bridge before capsizing. Back in the 1950s, when the Kappa Regatta was inaugurated, all boats had to be homemade. Outlandish vessels were made of barrels, wooden tubs, ladders, and ingenious inner-tube contraptions. Even an icebox freezer competed. In later years, canoe and rowboat classes were added. (Courtesy of the *Herald*.)

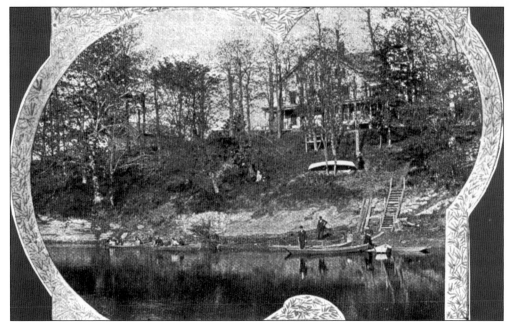

Riverside Cottage guests enjoyed strolling the shady grounds, boating on the Wallkill, and dancing in the adjacent Blue Haven Casino. Already impressive with its 26 bedrooms and dining room that could seat 110 people, the cottage underwent improvements in 1898 that included summerhouses, benches, and swings on the banks of the river. Guests also discovered a soft drink building and candy factory at the newly advertised "Pic Nic Grounds, Riverside Park." (From the April 1897 *Normal Review*.)

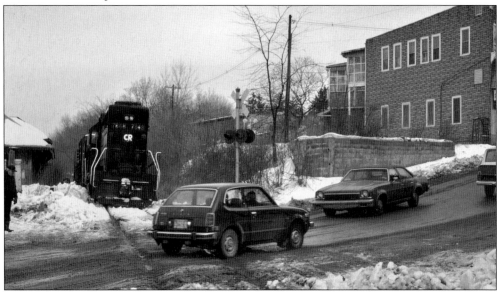

The Wallkill Valley Railroad continued to provide regular freight service until December 31, 1977. An occasional locomotive would creep through town after that date. The railroad line was abandoned soon after this locomotive derailed just north of the lower Main Street crossing in December 1978. By 1991, the New Paltz and Gardiner sections of the rail bed had been converted into the Wallkill Valley Rail Trail. (Photograph by William Rhoads.)

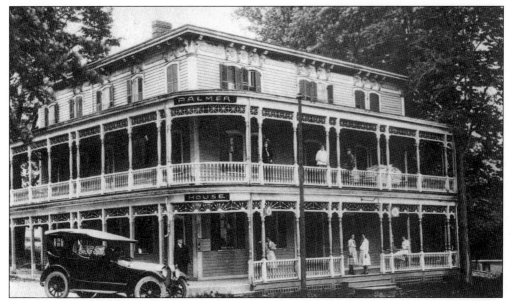

For a brief period before 1900, New Paltz had a reputation as a risqué carnival town. The racetrack on the flats drew large betting crowds. Local sportsmen rubbed shoulders with Astors, Vanderbilts, Morgans, and Goulds at this Main Street address; all signed their names in the hotel guest register. By the time George Palmer owned the business in the 1920s, it no longer attracted the wealthy horsy clientele.

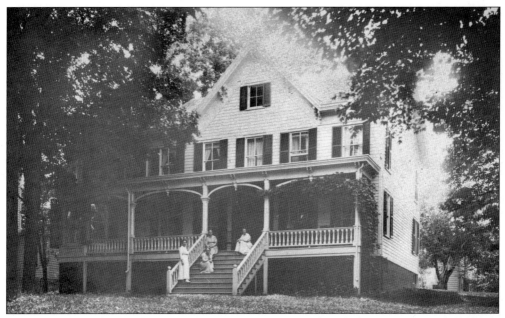

Four women on the porch steps at 26 Main Street are identified as Sara Deyo (standing), Elizabeth Marx, Mary Elting Deyo, and Margaret DuBois. Built in 1873 for Margaret DuBois's great-grandmother Susanna Church, the house once stood on the corner of Main Street and Wurts Avenue. The Elting Harp family (see cover picture) lived next door in a very similar frame house. Both houses were razed to make a parking lot.

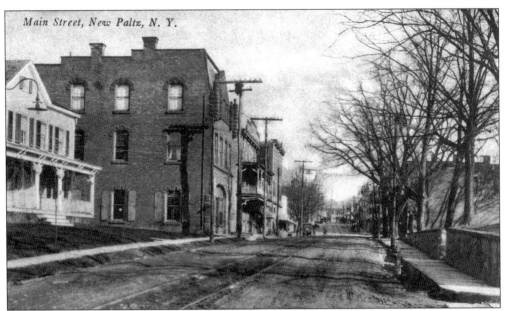

Main Street, New Paltz, N. Y.

The lower Main Street section depicted in this 1890s postcard has changed drastically. The frame house on the left and the Muller Hotel on the right are both gone. Only the bottom floor of the brick bank building survives, but it looks totally different with symmetrical additions to the east and west. The name of the original New Paltz Savings Bank remains etched in stone above the front door of the current bank.

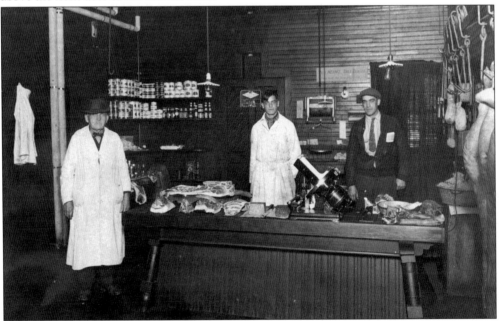

Known as the village butcher in 1880, Oscar Zimmerman (1848–1942) delivered meat to his customers in "a wagon painted in elegant style." Some 10 years later, he built a new home and meat market on lower Main Street. Zimmerman retired from the business at age 90, many years after having his picture taken in the market with an unidentified young employee and his son Jay Zimmerman. (Courtesy of Jay Zimmerman Jr.)

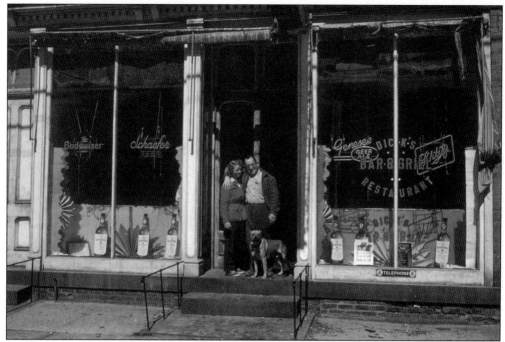

Although the village had its share of early establishments that served liquor, Dick's Bar and Grill was probably the first new local bar in the post-Prohibition era. Owned and operated by Richard V. Peterson for 25 years, the bar opened at 15 Main Street in 1933. This photograph was taken at his later 37 Main Street address a few years before the Hasbrouck building was torn down in 1958. (Photograph by Erma DeWitt.)

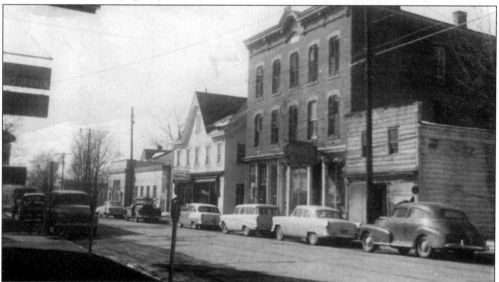

This 1958 snapshot was taken a few days before the three-story brick Hasbrouck building and its flat-roofed little annex were demolished. The cleared land became part of the new Grand Union Shopping Center's parking lot. The frame building with peaked roof, which had been Zimmerman's Meat Market, then Henry's Hardware, survived until 1970 when it was torn down. (Photograph by Frances Lathrop.)

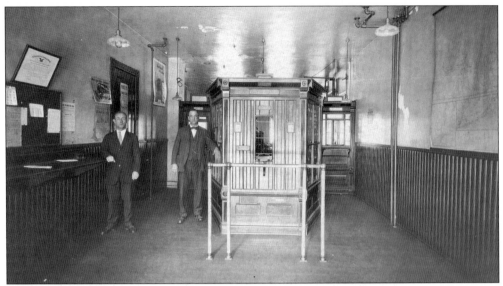

In the early days, the New Paltz Post Office hopped all over the village, rarely settling at any one address for long. The interior of the post office looked like this when it was located at 57 Main Street. Walter Hasbrouck, left, worked as a dispatch clerk for the post office from 1916 until 1953. Perry Deyo, right, was the postmaster from 1924 to 1932.

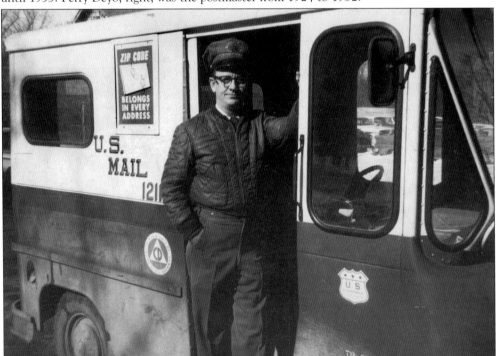

Before 1947, all village residents picked up their mail at the post office. When a home delivery system was established that year, house numbers were assigned to village residences for the first time. New street signs appeared. In 1963, Postmaster George Ackert announced the now familiar New Paltz 12561 zip code. Longtime postal worker Lew Schaffert poses beside his right-hand-drive mail truck in 1965.

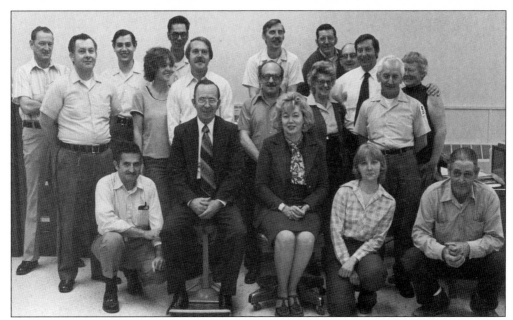

Postmaster Lillian Hall-Davis is surrounded by her fellow postal employees in this May 1978 photograph. They are, from left to right, as follows: (front row) John Coffarelli, James Olsen, Lillian Hall-Davis, Joan Wells Garcia, and Robert Conklin; (back row) David O'Neil, Frank Osterhoudt, Anthony Jerolino, Connie Smith, Harold Kerns, Thomas VanKleeck, Salvatore Fazio, Edward Hintz, Clara Morris, Charles Aube, Fred Hernwall, Bud Ingraham, Anthony Gill, and Patricia Smith. (Courtesy of Haig Shekerjian.)

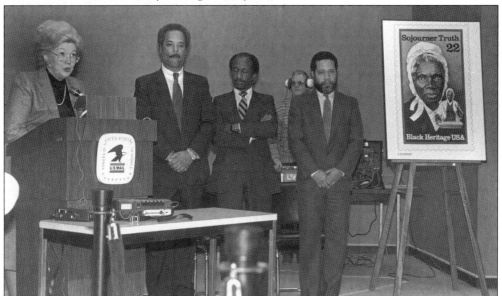

The Sojourner Truth Library on campus hosted the prestigious first-day-of-issue ceremony for the Sojourner Truth Black Heritage series stamp. The stamp design memorializes the former slave who became one of the leading crusaders for human rights during the Civil War. Sojourner Truth spent much of her early life in the New Paltz area. New Paltz Postmaster Lillian Hall-Davis speaks at the February 4, 1986 event. (Courtesy of the *Herald*.)

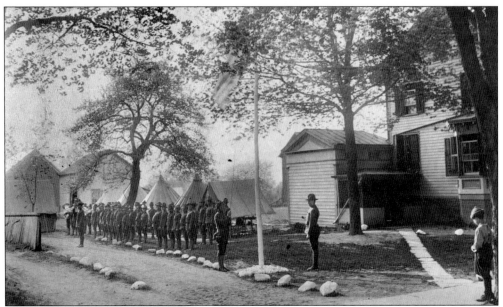

Officers and men of the 10th New York Infantry National Guard stand at attention near the corner of North Chestnut and Main Streets. The Magdelene DuBois house, then located at 3 North Chestnut Street, served as the group's headquarters in 1917. During World War I the infantry was stationed in New Paltz to guard the newly completed Catskill Aqueduct that passed through town in the Butterville-Canaan Road area.

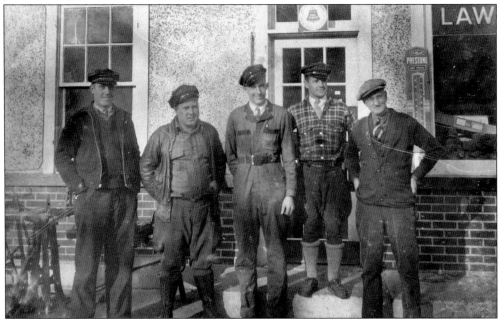

Wesley VanVliet (left) worked at Dan Lawrence's filling station as a youth before operating it himself from 1935 to 1965. Built in 1927 of stucco and brick with a red shingled roof, the building was replaced by a modern station in 1970. Pictured outside the old station with VanVliet, from left to right, are Harry Kaiser, Earl Slater, John Corwin, and an unidentified man. (Courtesy of Doris McElhenney.)

70

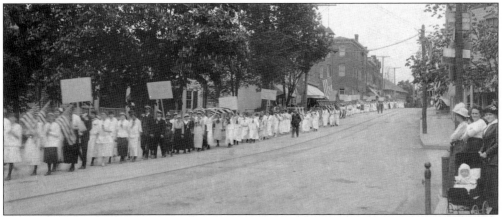

Few spectators rallied to support this 1916 march for an unknown cause. Mysteriously, while most participants are women, all the placards list local businessmen's names. Local suffragists did hold a convention in town that spring. Members of the Women's Christian Temperance Union called for the end of all liquor sales that fall. Women waited a few more years for the right to vote, but New Paltz became a dry town on October 1, 1916. (Photograph by H.L. Schultz.)

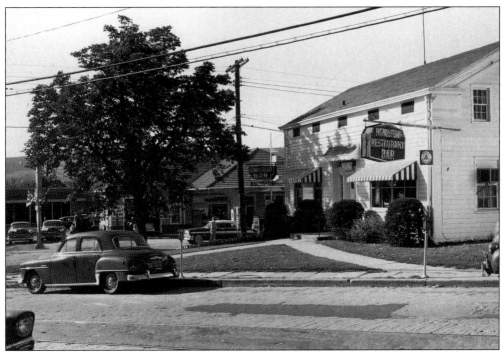

By the time this photograph was taken in 1958, the Homestead had become a popular restaurant under its proprietor, Wilson Lorenzen. Once a private home owned by the Coe family, the little eyebrow Colonial was moved a short distance back from Main Street in 1870. Coe's wife and two children remained in their house during the 25-foot relocation. (Photograph by Morris Rosenfield.)

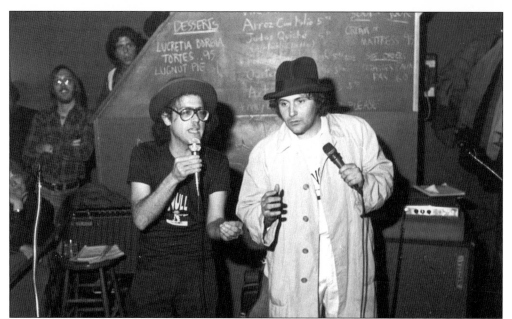

Dressed as narcotics agents, Mikhail Horowitz and Francesco Patricolo were photographed performing their skit "Who's on Smack?" at the North Light in 1978. It was to be their last performance together as the team Null and Void. The satiric skit was a spoof on the Abbott and Costello classic "Who's on First?" The restaurant hosted many musical groups, comedians, and poets during its years at 46 Main Street. (Courtesy of Mikhail Horowitz.)

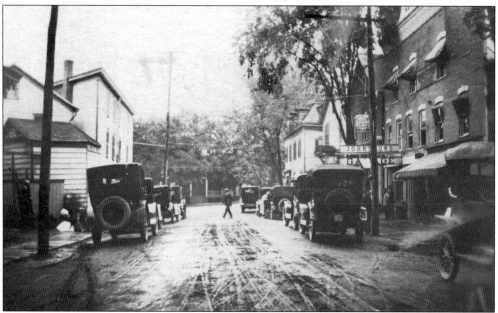

Three years after the first car drove up Main Street in 1900, George Johnston threw together a little shed on South Chestnut Street and began repairing radiators and crankshafts. His was the first garage in town—in fact one of the first in the entire Hudson Valley. Six years later, with business prospering, he built a three-story garage big enough to store 60 cars at once. Following a 1926 fire, only the ground floor survived.

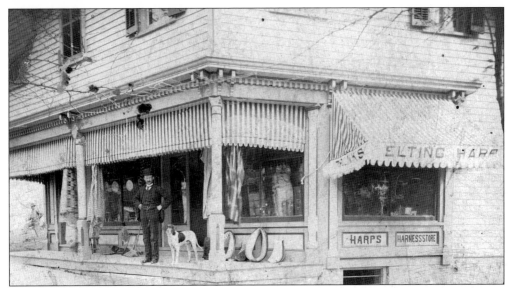

Elting Harp Sr. and his bird dog Die pose in front of his 52 Main Street harness shop. Note the horse blankets and collars displayed on the porch. Constructing this Empire-style building in 1887, Harp ran a successful business here until 1915. An avid sportsman, he trained bird dogs and acted as a guide for bird hunters. He penned a series of hunting articles for the *New Paltz Independent* in his later years.

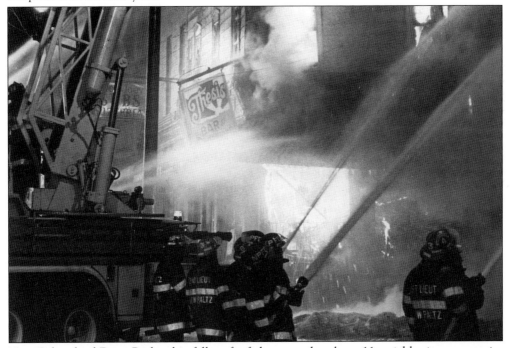

New Paltz chief Dave Butler, his fellow firefighters, and at least 11 neighboring companies responded to this early morning fire in February 1987. Hose freeze-ups in the subzero temperatures severely hampered efforts to save the 50–52 Main Street building. The fire destroyed two local businesses: the Thesis Bar and Chez Joey's pizzeria. Eight firefighters were injured in the blaze and seventeen people were left homeless. (Photograph by Ben Connelly.)

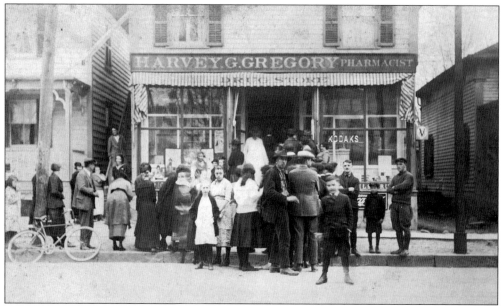

Harvey G. Gregory (1874–1945), graduate of the New York City College of Pharmacy, purchased an existing drugstore business at this 44 Main Street location in 1907 with partner Fred DuBois. He soon bought out the DuBois interest. Besides running a successful business, Gregory served as president of the village for seven terms and was president of the board of education for many years. (Courtesy of Harvey Gregory.)

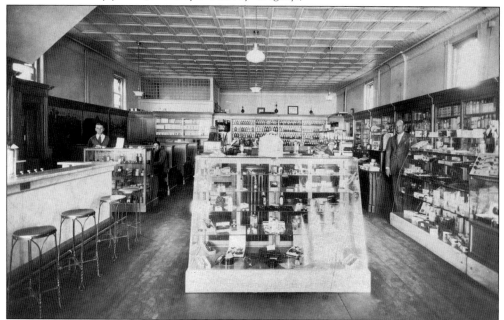

Tentatively identified as "Stubby," a longtime drugstore employee, the young man behind the soda fountain stands to the left of Harvey G. Gregory. Gregory moved all drugstore inventory one block east from his old location to this 58 Main Street address after purchasing the larger building in 1922. When he retired in 1944, he rented the brick building to the Grand Union for a self-service market. (Courtesy of Harvey Gregory.)

This young man with his feathers and cow skull was photographed in 1983 in front of 58 Main Street, then the Bomze and Van Vlack Pharmacy. For the past 30 years or so, these steps and others on lower Main Street have been popular gathering spots, often drawing together small groups of young people with time to spare. (Photograph by Jon Margolis.)

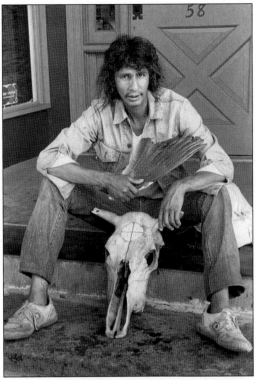

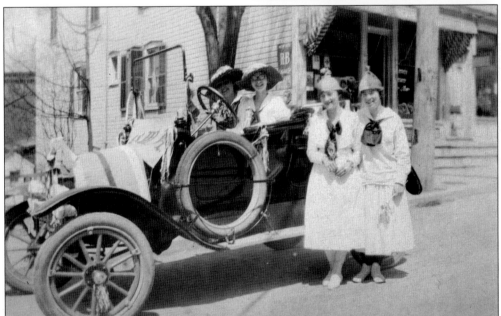

Marion Sutton decorated her father's Model T Ford to drive in the Liberty Day parade celebrating the end of World War I in 1918. She poses here with her friends on Main Street. Helena Gerow sits beside her, while Marie Williams and Edna Lawrence stand by the running board. By 1918, residents were already beginning to complain about the number of cars passing through the village, an estimated 2,000 on Labor Day.

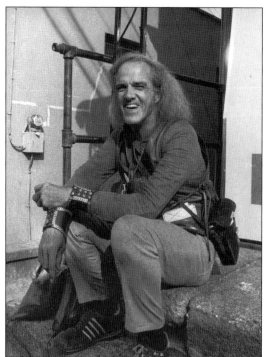

Ed Brandes arrived in the Wallkill Valley to claim a tract of forested land with an abandoned house owned by his mother. For nearly 30 years, Brandes began each day by walking or catching a ride to the village. He discovered that people discarded things that he valued. He decorated his clothes, house, and large three-wheeled bike with interesting cast-off objects. Brandes now resides in an Eddyville nursing home. (Courtesy of Haig Shekerjian.)

This flat iron building towers above the corner at Church and Main Street. Built in 1893 by the entrepreneur Burhans Van Steenburgh from Goshen, the large commercial space quickly became indispensable to the village. The village leased space for the lockup, the trustees' meeting room, and the fire department. The Star Hose and the Hook and Ladder companies stored their hose carts in the basement. Other tenants included a barber, a shoemaker, and a tailor.

Welcoming the after-school crowd to Osterhoudt's soda fountain located at 60 Main Street, Russell Rosa scoops up a seven-cent Hershey's ice cream cone for a lucky customer. As a newly married man, Rosa worked two jobs to support his little family. His night job was serving up beer and other liquid refreshments at Pat Cafferty and George Jayne's bar up the street. (Courtesy of Gertrude Holden.)

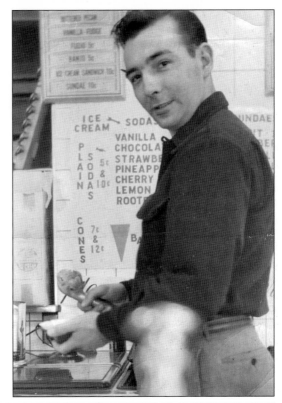

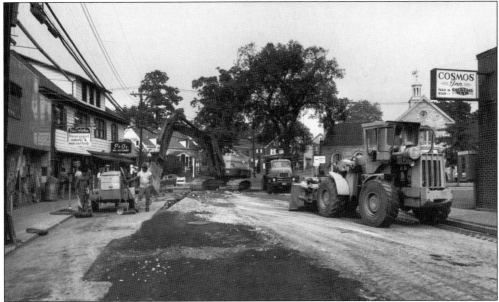

Laborers tore up Main Street in 1978 to replace the village's original sewer line. Built in 1893 by Burhans Van Steenburgh, the 2,000-foot line was laid beneath the street. For 78 years, raw sewerage flowed downhill through a pipe directly into the Wallkill River. An early article noted that the river flowed fast enough to "dilute to a safe degree all the sewerage that may flow into it from this village." (Courtesy of Haig Shekerjian.)

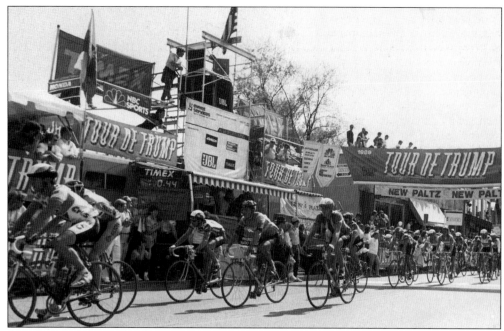

Accidents, construction, and parades can close down Main Street. However in May 1989, a completely different form of disruption caused traffic to be rerouted. Soviet cyclist Viatcheslav Ekimov beat out 113 world-class competitors in the first leg of the Tour de Trump. Ekimov biked 110 miles, from Albany through the Catskills to New Paltz, in 4 hours, 35 minutes, and 18 seconds. The 10-day, 837-mile race ultimately ended in Atlantic City. (Courtesy of Chamber of Commerce.)

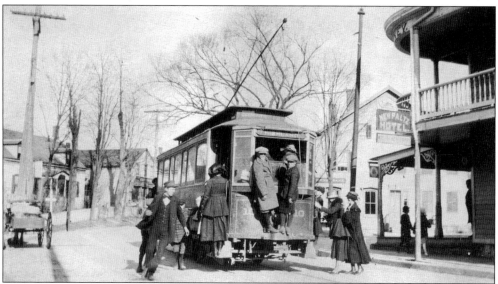

The trolley makes one of its regular stops on Main Street at Plattekill Avenue. After the hotel was razed, a gas station, since converted to a bookstore, was built near the corner. This 1917 photograph was snapped when the trolley was still providing reliable transportation between New Paltz and Highland. Eight years later the company was out of business, having lost customers rapidly as automobiles gained popularity. (Courtesy of Dennis O'Keefe.)

Local photographer Erma DeWitt captured "Old Glory" illuminated by strong afternoon sunlight in a 1945 Memorial Day scene. After the parade, the 300 marchers who participated were treated to soda at the American Legion Hall. New Paltz parades traditionally pass this central viewing spot near the Elting Memorial Library on Main Street.

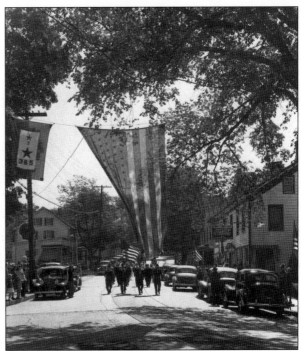

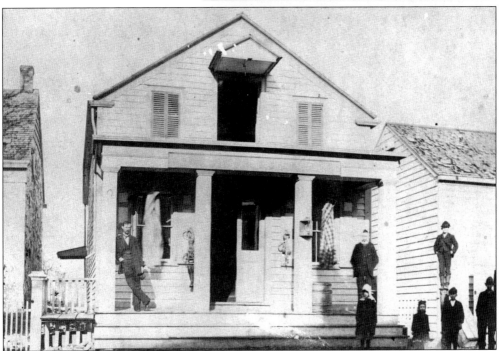

In 1910, George Van Nosdall ran a pool room, David Petty had a harness shop, and John Elting ran a tin shop; all these businesses were located at 101 Main Street. For nearly a century, various proprietors sold farm machinery, builder's hardware, dry goods, groceries, school textbooks, boots, and caps from this address. In 1922, a local newspaper noted that "the removal of this building improves the appearance of that part of the village."

Eight-month-old Florence Kaiser sits on her mother Emma Kaiser's lap, next to her 85-year-old great-grandmother Caroline Zimmerman. Grandmother Eliza Zimmerman Kaiser stands on the far right. Other family members include the father and the grandfather, William C. Kaiser Jr. and Sr., ages 32 and 63, respectively. This four-generation family portrait was taken near the Kaiser home at 106 Main Street.

William Kaiser Jr.'s son, Harry Kaiser (left), stands in front of his house at 106 Main Street with his friend Gordon Pine. Both boys were born in 1909; both wear knickers and high shoes. The house, probably built in the 1850s, was owned first by George Frear and then was sold to Elijah Woolsey before 1875. It was torn down in 1972 to open the lot for construction of Carroll's, a fast-food franchise.

In this casual group photograph taken by H.L. Schultz in 1916, Gordon Pine dangles a big puppy dog under one arm, and Harry Kaiser and Myra Sully hold on to a docile looking pet goat. Florence Kaiser steadies toddler Esther Townsend. The Kaisers owned a pair of goats that appeared as a harnessed team pulling a goat cart in local parades and celebrations.

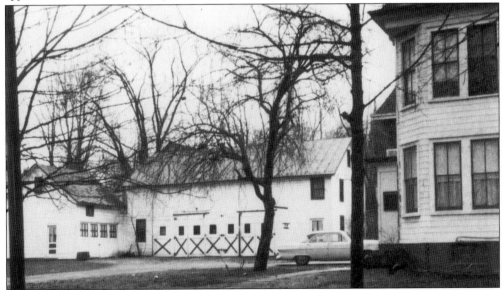

The bus station was once a series of barns that housed the livery business of Louis H. DuBois. When DuBois was young man, there were five Louis Duboises in town. To separate them, they were called "Libertyville Lou," "Wurts Avenue Lou," "Big Foot Lou," "Lop-eared Lou," and "Laughing Lou." Laughing Lou built the house on the right, which was taken down in 1970 to enlarge the parking lot. (Courtesy of Stewart Glenn.)

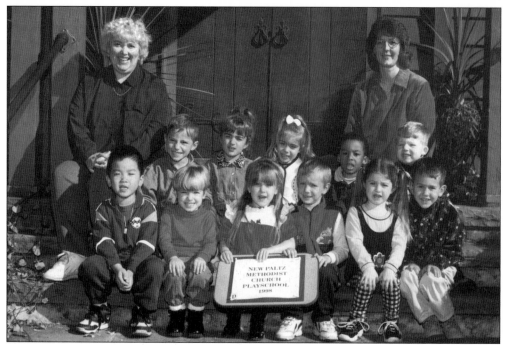

Teachers Linda Ackert and Sharon Babcock sit on the Methodist church front steps for a class picture with their play school students, who are, from left to right, as follows: (front row) Richard Chan, Rachel Jack, Sierra Pullman, J.C. Wilson, Melissa Neville, and Joe Fitzpatrick; (back row,) Anthony Pennes, Dominique Pennes, Taylor Reed, Blake Edwards, and Liam Kimlin. The play school was established 30 years before, in March 1968. (Courtesy of Linda Ackert.)

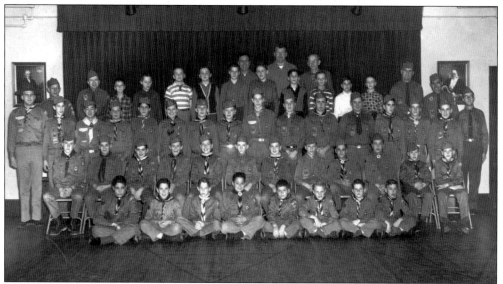

Members of Boy Scout Troop 77 held their meetings in the recreation room of the New Paltz United Methodist Church. This 1960 photograph appeared on a calendar produced by the troop to raise money for its programs. Pictured are Scout leaders Fred Sutter, August Martin, Herbert Ackerman, Matt Fairweather, and Bill Morris. (Courtesy of Stewart Glenn.)

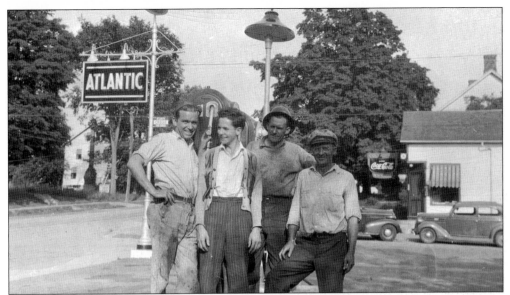

In 1942, when newly rationed gas was selling for pennies a gallon, Jansen's Garage located at the South Oakwood intersection on upper Main Street offered full service to customers. From left to right, Eli Hall, John Taylor Jr., Bob Jansen, and John Taylor Sr. pose on the lot. The College Inn Restaurant in the background was operated by Ed Carle for over three decades before his retirement in 1983. (Courtesy of Marie Jansen.)

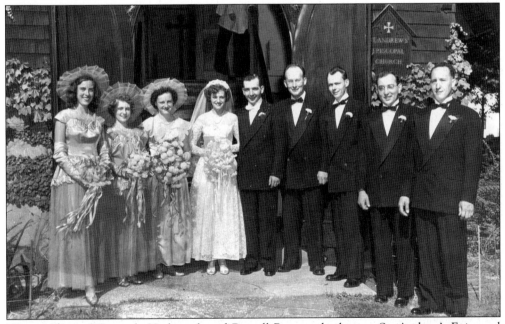

The wedding of Gertrude Hasbrouck and Russell Rosa took place at St. Andrew's Episcopal Church on September 23, 1951. The bride's ballerina-length Chantilly-lace gown had long pointed sleeves. Her headpiece of seeded pearls and rhinestones included a lace-trimmed fingertip veil. She carried a bouquet of white roses and carnations. The maid of honor's deep blue gown and the bridesmaids' coral gowns were satin with matching headpieces and mitts. (Courtesy of Gertrude Holden.)

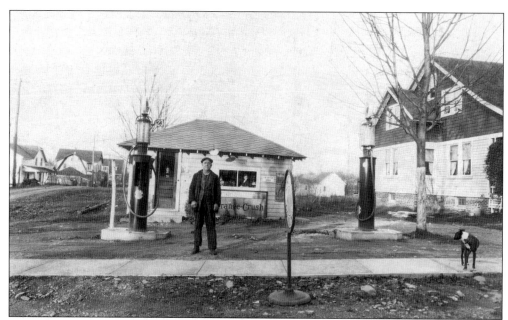

Motorists stopping at the two-pump gas station on the northeast corner of Millrock and Main Streets saw a large sign advertising Orange Crush. Smaller signs promised ice cream, hot franks, and clam chowder. The interior of the little square building is seen below. Proprietor Edward Keller (right, behind the cozy corner bar), established his business after moving to the village from Flat Bush, Brooklyn, in 1926. His daughter Catherine Keller (second from left) sits on a stool in this c. 1929 photograph. (Courtesy of Catherine Smith.)

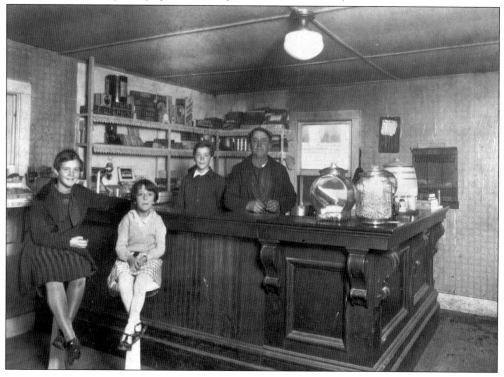

Photographer H.L. Schultz (1858–1921) left behind hundreds of priceless photographs of people, buildings, and events that clearly document and help visually define historic New Paltz. Posing for this formal portrait in Schultz's Church Street studio are Homer and Ida Minard Abrams. The couple lived at 184 Main Street before moving to North Ohioville Road. Abrams and his younger brother Ira Abrams worked together as general contracting carpenters in the village. (Courtesy of Martha McKenna.)

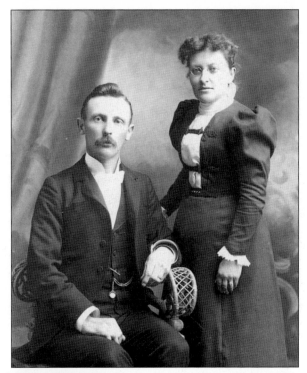

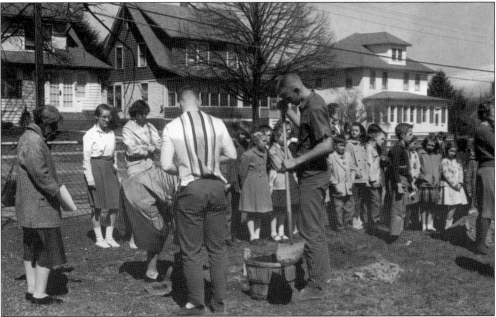

The New Paltz Garden Club coordinated this Arbor Day celebration in 1961. Honor Society high school students Herbert Van Valkenburgh and Carl Reed tackle the hard labor while students from the elementary grades stand by to support their efforts. The five trees planted that day grew to shade a bare stretch on school grounds along Main Street. Over the past 50 years, garden club members have beautified many neglected public spaces with plantings and follow-up care. (Courtesy of New Paltz Garden Club.)

Home from Wells College for the Christmas holidays in 1941, college freshman Elizabeth "Betsy" Lent plays cards with her Uncle Drew, father Harold Lent, and brother Dick Lent. Other members of the family, from left to right, are Uncle Perry Wilson, Richard P. Lent, Betty Lent, Katherine M. Lent, Mabel Lent, Jane W. Wilson, and Barbara Lent. The family home was the frame house at 275 Main Street. (Courtesy of Susanna Lent.)

The Lent house, barns, and other outbuildings were originally part of a 200-acre farm located about one mile east of the village center. In 1855, this farm produced 60 tons of hay and harvested 300 bushels of oats. Parcels of the farm were sold off at various times. George Crawford and a team of horses work on the Perry Wilson tract in the 1940s. (Courtesy of Susanna Lent.)

Four

WORK, PLAY,
AND WORSHIP

Les "Sonny" Wager of Jansen's Super Service changes a tire for a stranded motorist in 1957. Jansen's was the first local station contracted to provide service on the New York State Thruway. The Newburgh-to-Utica section officially opened on October 26, 1954, with a 500-car cavalcade led by Gov. Thomas E. Dewey. Some of the early tolls from New Paltz were Kingston, 20 cents; Albany, 85 cents; Buffalo, $4.35. (Courtesy of Marie Jansen.)

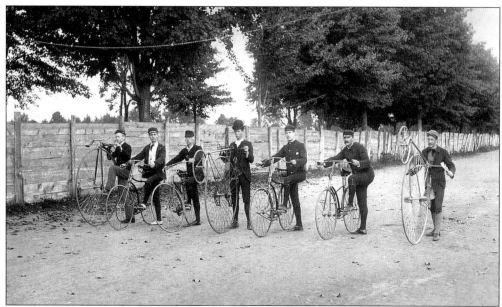

The bicycle craze of the 1890s involved both men and women. In September 1898, a local newspaper reported that three Travis sisters, Grace, Blanche, and Mabel, completed a month-long bicycle tour of the Catskills. A year earlier Grace had embarked on a solo trip between New Paltz and Woodstock. Area racetracks accommodated both bicycle and horse racing. These young men line up for a race at the Kingston Driving Park in 1890.

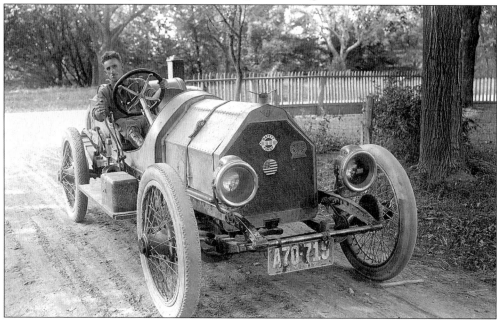

This vehicle arrived in town with the New York State Guard in 1917; it was ostensibly used to patrol the Catskill Aqueduct. On occasion, a young man named Van Alstyne took impressionable village girls for rides in "the sporty car." As the state guard prepared to leave a year later, the *New Paltz Times* noted, "The soldiers have meant much to the village in a social and a business way. Many lasting friendships have been made."

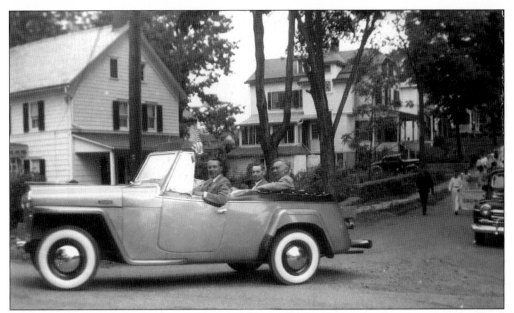

George Ackert chauffeurs Abe Paradies and Henry W. DuBois in his Jeep convertible. Until the war monuments were dedicated in front of the municipal building on Plattekill Avenue, Memorial Day parades routinely passed down Wurts Avenue on their way to the Rural Cemetery. Dr. George Wurts was the first physician in town; the Swiss name appears in town records by 1773. Sons Jacob and Mauritius Wurts, as well as two grandsons, became doctors. (Courtesy of Marjorie Ackert.)

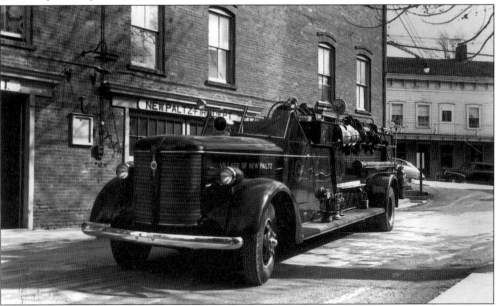

The New Paltz Fire Department's 1940 streamlined American LaFrance pumper is parked on Church Street in front of the old firehouse. The truck was so long and the firehouse doors so narrow that the truck always had to exit the building to the north. As soon as World War II was over, firefighters started to call for a new firehouse, which was finally completed in 1950. (Photograph by Erma DeWitt.)

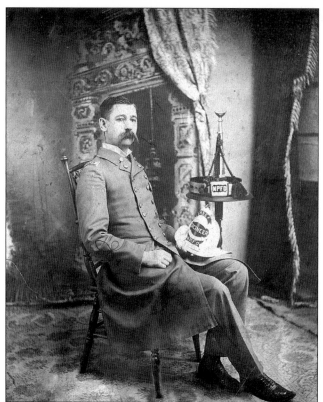

George E. Rust was chief engineer of the New Paltz Fire Department at the time of his death in April 1898. Four months earlier, he had resigned from his job as a teller in the Huguenot Bank due to failing health. Rust died at his parents' home in Poughkeepsie in his 37th year, leaving behind a widow and three children. (Photograph by H.L. Schultz.)

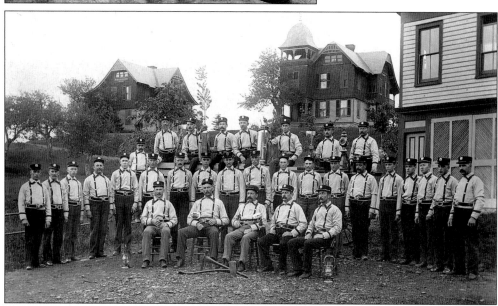

Organized in 1889 as a bucket brigade, the Ulster Hook and Ladder Company No. 1 purchased a hose cart in 1892. The firefighters attached 200 feet of hose to a hydrant, which was part of the newly completed waterworks system. In the first test with only one-third of the full stream turned on, "the water flew above the tops of the buildings." Attempts to identify the local firefighters in this undated photograph have not been successful.

Extravagant carnival and block parties were held in the 1920s at this commercial intersection known then as the Village Square or Tamney Square. In 1978, the Memorial Day Parade route passed beneath still healthy branches of the corner elm. Arborist Dwight Bayne's efforts to save the tree failed. Many spectators watched in 1997 as a village work crew cut down the 150-year-old elm, a victim of Dutch elm disease. (Courtesy of Haig Shekerjian.)

The annual report of the village police for 1959 included 9 investigations of fights at bars and grills, 14 arrests for public intoxication, 5 reports of shoplifting, 4 reports of gas stations leaving merchandise out overnight, and 42 reports of doors left open by business people. Fourteen motorists reported hitting deer; 735 parking tickets were issued that year. New Paltz village police officer Hank Tifferman is ready for anything.

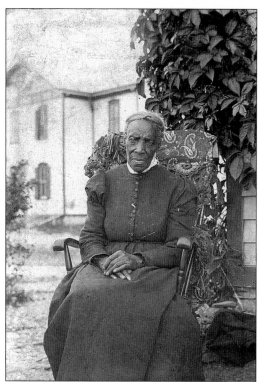

"Aunt" Judy Jackson (1800–1898) spent her first 27 years as a slave on the Jeremiah Merritt farm, now the site of the Ulster County fairgrounds on Libertyville Road. She told memorable stories about wild animals that roamed the forest in her youth. Once while herding cows up from the river at dusk, she caught sight of a panther lurking in a tree. The panther sprang for the cows but missed his prey. (Courtesy of John and Katia Jacobs.)

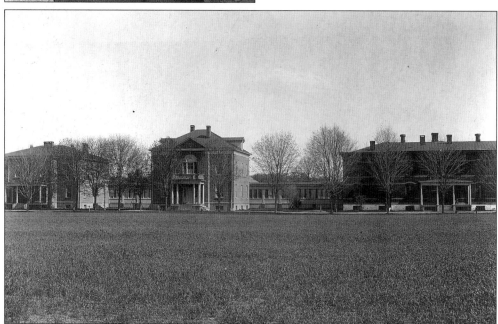

Between the years 1827 and 1977, the Ulster County Poor House on Libertyville Road was a shelter for sick, handicapped, elderly, and homeless county residents. Until 1890, the mentally ill were also housed there. A cemetery on the property is the final resting place for over 1,000 destitute people from the county. All buildings were demolished in 1985 to make room for the growing Ulster County Fair. (Photograph by H.L. Schultz.)

Local farmer Marshall J. MacMurdy proudly shows off his team of draft horses that placed second in their class at the Ulster County Fair horse show in 1937. The fair, which was founded in Ellenville in 1886, had just moved to Kingston. In 1967, the fair moved once again to the Ulster County Farm and Poor House site and has been at the New Paltz location ever since.

Organized in 1944, the Public Health Nursing Committee's stated goal was to improve the general health of the community. At the time, children were being immunized against smallpox. Vaccines for measles, rubella, mumps, and polio were still in the future. Committee members assisted local doctors at monthly clinics for preschool children. They also loaned out hospital beds, wheelchairs, and crutches from a central closet. (Photograph by Erma DeWitt.)

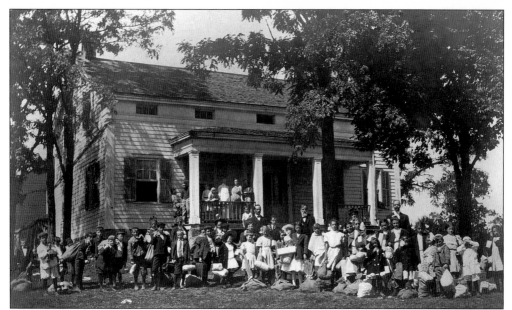

Multimillionaire coffee and sugar merchant John Arbuckle (1838–1912), a frequent Mohonk guest, went on a local buying spree in 1903. He acquired seven farms, including the Smedes place on Libertyville Road. Calling his 800-acre spread the Mary and John Arbuckle Farm, he began importing needy children from Brooklyn for short summer stays. According to Arbuckle, "The boys all wanted to help with farm work and the girls around the houses." (Courtesy of Geraldine Buck.)

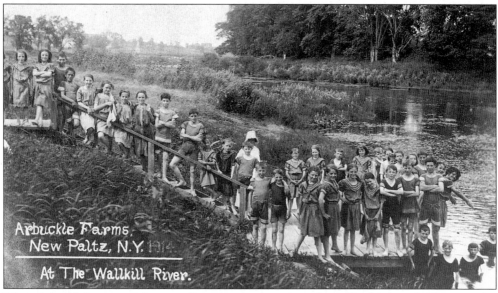

John Arbuckle's niece Margaret Jamison continued to host Fresh Air children at the farm until 1938. Each summer young boys and girls arrived in groups of 40. Margaret Jamison added amenities to the two-week-long country experience. She purchased 40 single beds to replace earlier tents, added a dock and bathhouses to the Wallkill swimming area, and built tennis courts. Her estate was valued at $40 million when she died in 1942. (Courtesy of Geraldine Buck.)

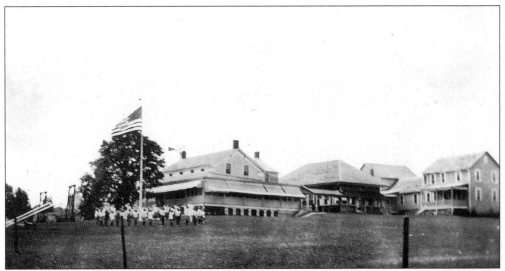

Beginning in 1917, the Fresh Air children played rainy day games, ate their meals, and watched movies in the spacious playroom. The new separate building was designed to accommodate 40 children at once. The kitchen and sleeping dormitories remained next door in the old Smedes farmhouse, renamed the Children's Cottage. Local women hired to care for the children included Emma and Ruth Mertine. (Courtesy of Geraldine Buck.)

The rhinoceros spends a last tranquil minute in the playroom where he was sculpted out of cement by SUNY art professor Judith Sigunick. Professional movers have arrived to complete the tricky operation of getting him out the door, onto the truck, and transported to the Rosendale Recreation Center. The spacious playroom stood empty for years but has been used recently as a carpenter's shop and studio space for artists. (Photograph by Will Faller.)

95

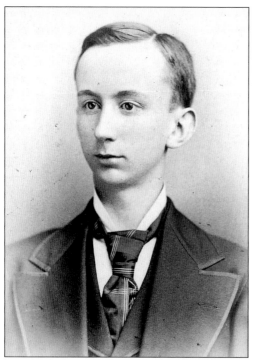

Abram Jansen (1858–1944) was the first fruit grower in the United States to grow McIntosh apples commercially. The famous apple originated on the McIntosh homestead in Canada, but the credit and honor for discovering its fine qualities and commercial value belong to Abe Jansen. The McIntosh quickly became the leading dessert and cooking apple in New York. Jansen stored the apples in the first electrically operated cold storage unit built on an American farm. Located on Route 32 South, the Jansen farm was purchased by the Wright family.

Born in Italy, Joe Moriello (1908–2000) immigrated to America with his family in 1914. He became a partner with his younger brother Mike Moriello on a fruit farm that Mike had purchased at a foreclosure sale in New Paltz. Since 1945, three generations of the Moriello family have updated and expanded the family business to include a large packing and storage facility and a successful fruit stand. (Courtesy of Sheila Moriello.)

Even before William Illensworth's granddaughters moved to New Paltz from Philadelphia in 1939, they made friends with their grandfather's workhorses during visits to Hillcroft, the family's farm on South Putt Corners Road. Martha and Ruth handle the white mares Bessie and Pet; only Mary seems cautious. A few years after this photograph was taken, the sisters moved to the village where Mary and Martha still live today. (Courtesy of Martha McKenna.)

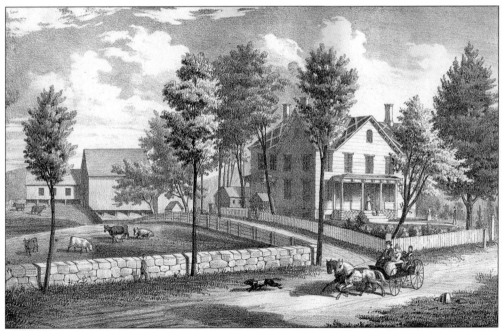

Destroyed by fire in 1915, this Lefevre family homestead was the home of two former members of Congress from New Paltz: Jacob LeFevre and his son Frank LeFevre. Located on land that had been in the family since 1748, it was called Eikayo Orchards. The house stood on the site of the present Moriello apple cooler. Many of the tenant houses, barns, and outbuildings remain in use today. (From the *County Atlas of Ulster*, New York, 1875.)

An apple picker harvests McIntosh apples at Dressel Farms in 1983. Each year about 1,500 Jamaican workers arrive in the Hudson Valley to pick apples under an international agreement involving the United States, New York, Jamaica, and the apple growers. The importation of foreign workers dates back to 1943, when there was a shortage of farm help because of World War II. The agreement continues because of the desire of the Jamaican workers to come north to earn better wages and the reluctance of Americans to work in farm fields. (Photograph by Jon Margolis.)

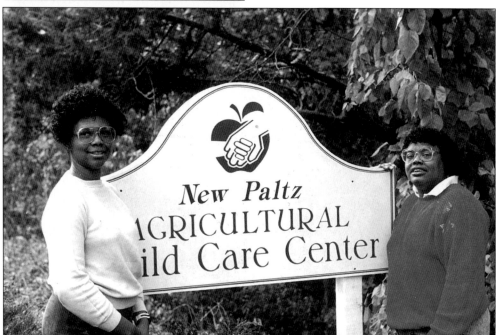

Since the early 1960s, there has been a day care center for migrant children in the New Paltz area. Originally housed in various schools, as well as in the former county home complex, the center moved to its own Route 32 North facility 16 years ago. Currently named the Agri-Business Child Development Center, it was called the Agricultural Child Care Center when this photograph of staff members Debbie McSwain and Hildred Davis was taken.

Sometimes spring floods drown fragile seedlings. More often gophers or deer stop by this spot to dine, as they have for the past 25 years. Nevertheless, the majority of gardeners who cultivate their 20-by-30-foot plots in the Gardens for Nutrition stick out the season and return the following year. Each spring, about 150 gardeners gather down by the Wallkill River to begin planting on the communal site owned by the village.

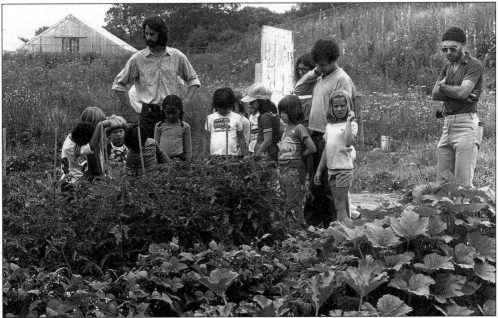

On a summer day in 1977, Mara Lavergneau, with pigtails, and other children from the Unison Learning Center's Earth, Air, Fire, and Water Day Camp search for ripe tomatoes in a well-tended garden plot. Mara stands in front of Glenn Gidaly, director of Gardens for Nutrition. It had taken just two short years to convert three acres of this weedy floodplain into a community showplace of productive gardens.

Lauretta Freer Dimsey portrayed a French girl in the June 1924 Huguenot-Walloon Celebration. She was one of over 600 local residents cast in an extravagant historical pageant directed by Normal School professor Bruce Bennett. The entire event was staged outdoors, both on Huguenot Street and in the meadows adjacent to the stone houses. A regimental band and a large community chorus provided the music.

Martin and Harry DuBois took on the roles of the patentees Abraham and Isaac DuBois in the 1924 pageant. A large costume committee, chaired by Helena Olds and Mrs. Harvey G. Gregory, designed and stitched together everything from these men's outfits to costumes for children portraying butterflies, bees, and a robin.

The centuries seemed to melt away, as costumed villagers assumed Colonial roles during the tercentennial celebration in 1978. Rain and high winds played havoc with the painted pageant backdrop and rehearsals, but the cast of nearly 500 pulled together to portray the story of the early Huguenot settlement of New Paltz. SUNY professor Frank Kraat directed the massive production; Mary Vett was the costume mistress. (Photograph by John Giralico.)

Sporting tailored mint green tuxedos on St. Patrick's Day, Corny Taylor, Tom Upright, Paul Benson, and other members of Benson's Brigade dance the Irish jig down Main Street. Spectators and revelers spent the afternoon meeting up with friends along the crammed parade route before wandering off to local establishments for corned beef, cabbage, and pitchers of green beer. (Courtesy of Joe Smith.)

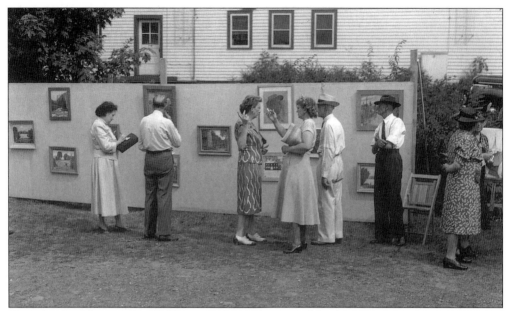

On a Sunday afternoon in 1948, over 300 people stopped by the New Paltz Art Association's First Outdoor Art Exhibit. Visitors were asked to vote for their favorite paintings. *Hydrangea Still Life: Rondout Canal*, by Myra Gerald, edged out 63 other entries as the overall favorite that summer day. Second and third choices were *Pastel Landscape*, by Arthur Kurtz, and William Bracken's *Reformed Church*. (Photograph by Erma DeWitt.)

Erma DeWitt (1907–1999) became a serious professional photographer in the 1940s, focusing her lens on local people, buildings, and events. In 1947, she completed a photographic documentation of all the stone houses in Ulster County. Many of her early photographs are reproduced in this book. As a young mother with three children, she also worked long hours as a trained nurse in her husband Dr. Virgil DeWitt's busy general practice. (Photograph by H. Brown.)

By the time John Giralico worked on this stage set in 1979, the community theater group called Ninety Miles Off Broadway was already in its 15th season. Directed by Frank Kraat with set design by Gary Prianti, *Fiddler on the Roof* starring Joe Paperone as Tevye and Maryann Friedman as Golde drew rave reviews. (Photograph by Glenn Weston.)

In the late 1980s, the Huguenot Players performed on stage in the Methodist church basement. The company built collapsible modular bleachers and otherwise transformed the space into an intimate theater. Productions included *Look Homeward Angel*, *Outward Bound*, and *Mornings at Seven*. Five of the Huguenot Players, from left to right, Michael Dixson, Oliver Berg, Bill Connors, Richard Cattabiani, and Don Wildy, appear as themselves in this 1989 publicity photograph. (Photograph by Haig Shekerjian.)

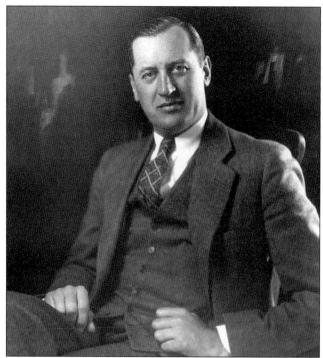

Four-term Congressman Jay LeFevre (1893–1970) was first elected by the 30th Congressional District in 1942. As a member of the Special Committee on Post War Economic Policy and Planning, he visited postwar European countries, as well as Russia. Following an interview with Joseph Stalin, he described the Communist leader as "a very strong man, one intensely interested in the welfare of his country." (Courtesy of Jay LeFevre Jr.)

The New Paltz Chapter of the League of Women Voters of New York State was organized in 1946. The League publishes a brochure, *Facts for Voters*, updated each year with information on statewide candidates and propositions for the upcoming November election. Local members ceremoniously present the 1963 edition to candidates for town supervisor. Pictured, from left to right, are Mrs. Robert Shuler, Peter Savago, John Schreiber, and Mrs. Leonard Tantillo. (Photograph by Morris Rosenfield.)

Moments before the photograph was taken, the Pritchet twins, five DuBois children, and seven other children popped out from behind their respective gift-wrapped boxes. Santa, of course, sprang from his hiding place inside the large "S" box during the 1948 Huguenot Grange Christmas party festivities. The Huguenot Grange was organized in 1905 and met from 1922 to 1968 in the Grange Hall, then located on North Chestnut Street. (Courtesy of Rosalie Nelson.)

New Paltz Rod and Gun Club members had this 1949 photograph taken inside their old clubhouse just four years before it burned down. Located about three miles north of the village on the Wallkill River, the building was originally part of a local Boy Scout camp. An annual barbecue and field day commemorates the completion of the new clubhouse that was rebuilt at the same location. (Courtesy of James Palkowics and Marsha Barbarito.)

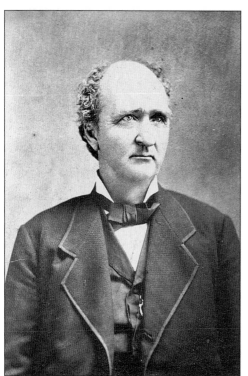

The Reverend Dr. Charles H. Stitt (1819–1881), minister of the Reformed Dutch Church for 17 years, spoke at the dedication of the New Paltz Rural Cemetery in 1861. The text of this lengthy address survives, as well as the service he performed at the Civil War funeral of Johannes LeFevre. In his *History of the Huguenot Church and Settlement at New Paltz,* he included brief characterizations of the ministers who preceded him in the pulpit.

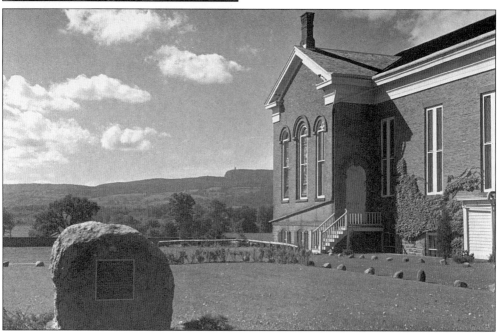

Originally built of stock brick by Abel Saxton in 1839, the Reformed Church was enlarged in 1872. Poughkeepsie architect J.A. Wood designed the 70-by-24-foot addition to the west. His plan, which called for transepts, seen here in 1933, significantly changed the simple rectangular shape of the original church. The view of the Shawangunks and Sky Top opened up only after church sheds were taken down in 1932. (Photograph by Daniel Smiley Jr.)

Salvatore and Rose Livolsi sat for this snapshot in front of the first St. Joseph's Catholic Church. Once upon a time, these steps connected with South Chestnut Street, as seen below. Recently nicknamed the "steps to nowhere," they still exist but are now useless. A chain-link fence blocks access to the street. The building pictured here was razed in 1965 to make space for the present much larger church. (Courtesy of Betty DuBois.)

Built in 1893 by local contractor Jesse Steen to accommodate 240 worshippers, the original church did not have a steeple until 1906. The massive stone wall designed to enclose the entire St. Joseph's Catholic Church property appeared 19 years later. Before construction of the present modern church, this lovely little church became seriously overcrowded. (Courtesy of St. Joseph's Catholic Church.)

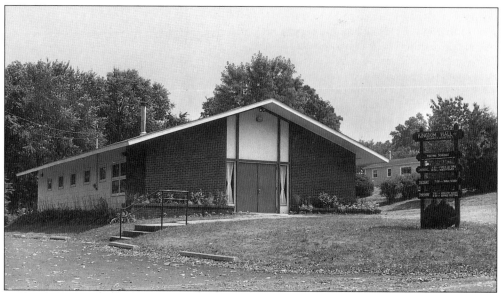

The Kingdom Hall of Jehovah's Witnesses in New Paltz is located off Route 32 North on land donated by Bertha Van Alst. In 1960, the Newburgh Congregation of Jehovah's Witnesses had grown to such an extent that the congregation was split to form the New Paltz branch. In 1991, the church owned 3,865 acres of land in New Paltz and the surrounding towns of Gardiner, Rosendale, and Shawangunk. (Photograph by Lauren Thomas.)

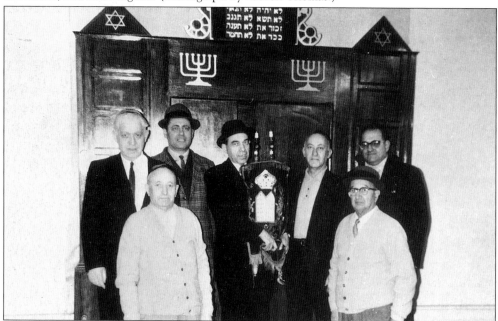

Congregation Ahavath Achim was founded in 1964 by a small group of Jewish families who purchased the building at 8 Church Street and converted it into a synagogue. The 1840 sanctuary had been both a Methodist and then a Lutheran church. In 1997, the membership of the synagogue officially changed its name to the Jewish Congregation of New Paltz. The Hebrew name *Hehilat Ahavath Achim*, meaning "congregation of brotherly love," is maintained in an extended title.

George Ronk led more than 300 people in song to begin the dedication services for the new Church of the Nazarene in 1963. Pastors from neighboring churches and communities joined the congregation to celebrate. Founded in the late 1920s, the church first met in the old African Methodist Episcopal Zion Chapel on Pencil Hill Road. Services were held in the American Legion Hall and the Huguenot Grange building in the late 1950s. (Courtesy of Rev. David Trauffer.)

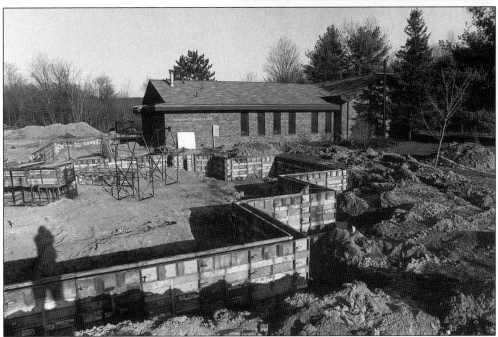

The sanctuary that is being added on to the Redeemer Lutheran Church in 2001 is the second phase of a three-phase building project. The original parish hall with its classroom wing was built in 1965 on Route 32 South. According to the projected program, the final phase will be the construction of an extension to the existing classrooms. (Photograph by Lauren Thomas.)

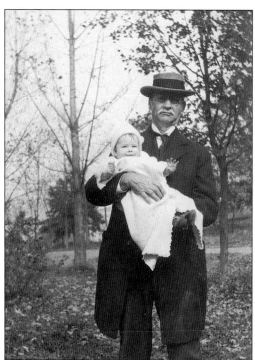

The young Ralph LeFevre (1844–1925) worked briefly and unhappily as a farmer, a schoolteacher, and finally a bank teller. He did not discover his true calling until he took over the *New Paltz Independent* in 1869, becoming publisher and editor of the weekly newspaper until his death in 1925. Author of the classic *History of New Paltz*, published in 1903, he poses with his first grandchild, Esther Elizabeth, who was born on January 22, 1916.

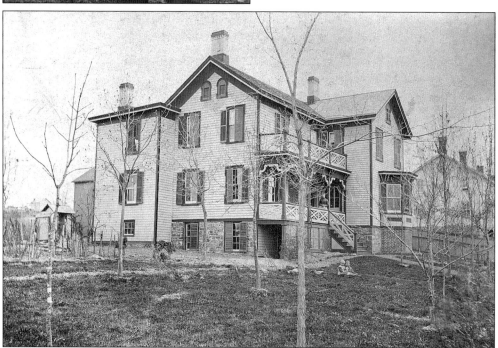

Ralph LeFevre bought this house at 38 Elting Avenue in 1878 for his family. Fourteen years later his wife, Esther Margaret LeFevre, embarked on a two-month European trip with her brother. After three weeks abroad, she wrote to her adolescent children, "I could go to Europe [for] two weeks and see all that I wanted to. I get soon tired gadding about all the time. Europe is very good but I like home better."

He had a cigar factory in Manhattan and three more in Key West. He marketed registered cigar brands named the Baron, Iron Duke, and the Patentee. Born in Ulster County and educated in Kingston, William E. DuBois (1849–1933) returned to the area in 1899 as a wealthy businessman with Cuban connections. He built a 14-room home for his family on an 87-acre tract at the end of Prospect Street.

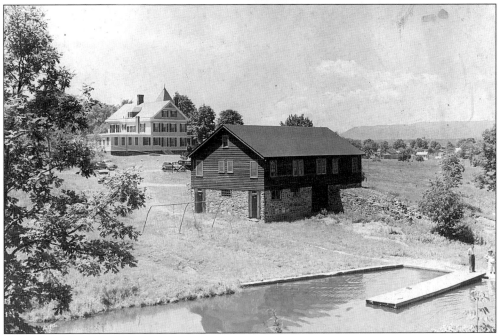

In 1932, Daniel Shaw bought the entire William DuBois property, including "one of the best built and finished mansions in this part of the country, two modern bungalows and a new barn," for $12,000. He immediately built a large swimming pool and pond by erecting a 60-foot-long dam across the Mill Brook. Within a year, he sold the property to Josef and Julia Bruckmayer, who ran the Millbrook House as a summer resort for 25 years.

British born David C. Storr (1852–1924) moved his family to New Paltz from Manhattan in 1905. Within 10 years, he was the largest property owner and taxpayer in the village, having built 20 rental cottages and bungalows in the Oakwood Terrace area. His improvements there included new or extended streets, a picnic grove named Oakwood Park, and a centralized water system with a reservoir that supplied all the new dwellings.

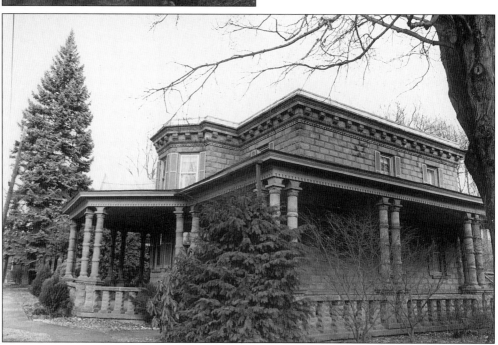

D.C. Storr rented an old coal shed and ordered machinery for manufacturing concrete blocks. His innovative factory ran day and night in 1907, producing four blocks an hour. He used some of them to build columns for his frame cottages. This 26 North Oakwood Terrace house, photographed with a wide-angle lens in 1991, was constructed entirely from the concrete blocks, which looked like rough-dressed stone. (Photograph by Julie O'Corozine.)

Mrs. Henry W. DuBois and her daughter Mary Catherine DuBois sit on the steps of a local airplane observation post. Established nationwide as results of the World War II bombing of Pearl Harbor, these posts were staffed by volunteers. To keep this Manheim Boulevard post functioning around the clock, 492 men and women logged 12,383 hours from the evening of December 8, 1941, to midnight February 28, 1943. (Courtesy of Mary DuBois Debelack.)

Henry W. DuBois was the mayor of New Paltz from 1958 to 1975, serving longer than did any other mayor in the history of the village. He selected Joanne Taylor as the VFW Buddy Poppy Girl in May 1962. She is the daughter of Betty and John Taylor, a World War II veteran. The distribution and display of the poppy flower is a symbol of remembrance to honor all war veterans.

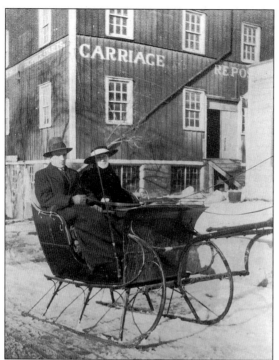

Back when two-way travel was allowed on North Front Street, many people used cutters in the winter to navigate on the ice and snow. Horses were stabled in the livery; sleighs and carriages were built in this four-story carriage shop, which now houses Handmade and More. In 1932, Marion Sheeley removed the top two floors, constructed a brick addition, and converted the building into a service station. (Courtesy of Ruth Hirsch.)

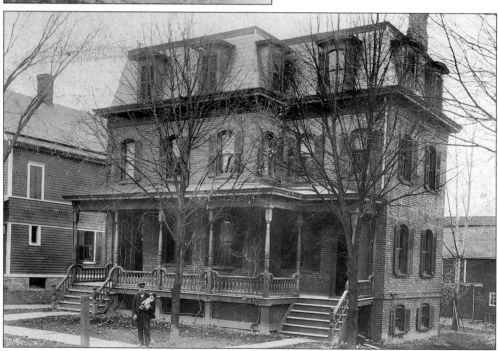

Born in Cassel, Germany, William Conrad Kaiser Sr. (1843–1925) had moved to New Paltz by the time he married Eliza Zimmerman in 1870. Father of four daughters and a son, he was a successful barber with shops on Main Street. Kaiser stands in his front yard in 1913 holding his small dog. Built in 1892 with bricks from Low's local brickyard, the house at 39 North Chestnut Street features a Second Empire-style mansard roof.

Although the business was named the Rosendale Electric Company, it was located in New Paltz at 25 North Chestnut Street. This 1953 photograph shows employees assembling small radio parts. Among those pictured are Evelyn Scott, Rose Alessi, Helen Mueller, Helen Sutherland, Mary Krum, Louise Dooley, and Gertrude Roosa. The building is now owned by Bruce and Sandy Hansen, who operated a T-shirt store there for many years. (Courtesy of Gertrude Holden.)

Advertised in 1969 as the "The Clothing Store; the Little Blue Building with Stars and Clouds Forever," this 5 Church Street address soon became known as the Cloud House. High Falls artist Robert Schuler decorated the building for his friend Michael Horbund's new business. Reflecting hippie counterculture trends, the store sold velvet opera coats, handcrafted leather, psychedelic shades, pipes by Sagiquarius, military surplus, chambray work shirts, and Apache scarves. (Courtesy of Haig Shekerjian.)

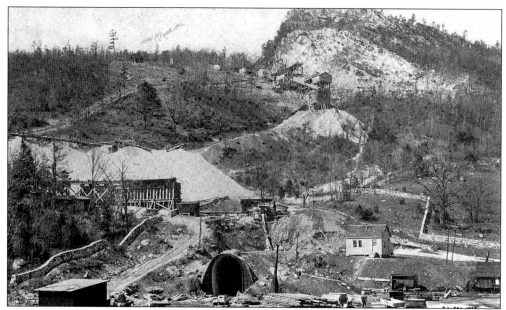

The 17-foot-high Bonticou grade tunnel begins the local section of the 126-mile-long Catskill Aqueduct, which currently channels millions of gallons of water daily from the Ashokan Reservoir to New York City. Many Butterville and Canaan Road properties were condemned to provide the necessary right-of-way, as well as temporary housing and office space for the massive construction project. (From the *Seventh Annual Report of the Board of Water Supply of the City of New York.*)

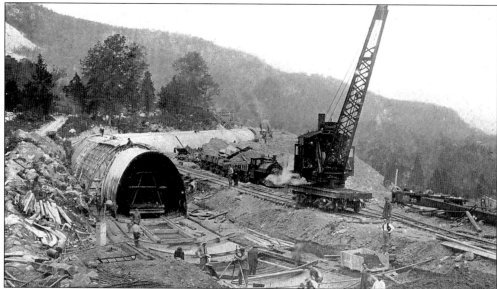

As work on the aqueduct progressed, technical words like pressure tunnel, cut-and-cover, grade tunnel, and siphon chamber crept into the local vocabulary. Here is an inside view of a cut-and-cover operation. Laborers position steel reinforcement rods while others build up the earth embankment. A local newspaper reported the presence of "some Negroes and some Italians," as well as Austrian and Polish laborers. The contractors admonished local saloons not to sell liquor to the workers. (From *Catskill Water Supply: A General Description and Brief History.*)

Massive concrete piers still mark the location of this steep blasting site at the base of the Bonticou outcropping. After passing through New Paltz, the aqueduct tunneled beneath the Wallkill River and the Hudson before heading south toward New York City. Flatcars shuttled back and forth between Bonticou and the Wallkill site on temporary rails, transporting crushed stone at the rate of 30 carloads a day. (Courtesy of Vivian Wadlin.)

Fearing sabotage during World War I, three armed guards patrol the fenced section of the newly completed Catskill Aqueduct, which crossed under Mountain Rest Road. About 200 men lived at Fort Orange, a temporary camp located nearby on the eastern slope of the Shawangunks. In the 1920s, the contractors began selling all the properties they had acquired previously under powerful laws of eminent domain.

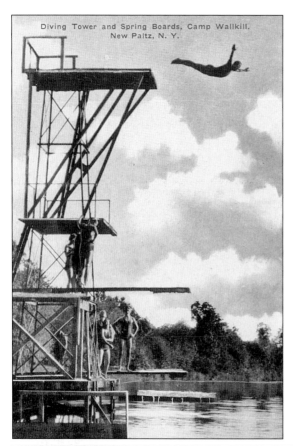

A camp counselor dives into the Wallkill River from a steel tower. A swimming crib for beginning swimmers was located nearby, as well as a complete manual training shop and rifle range. Located three miles north of the village, Camp Wallkill also included a large dining hall (below) and a recreation hall equipped with a stage, piano, Victrola, pipe organ, and "wireless" music. The camp was purchased by the Archdiocese of New York and run by the Catholic Youth Organization. It was renamed Camp St. Agnes and later, Camp Dineen. (Courtesy of Vivian Wadlin.)

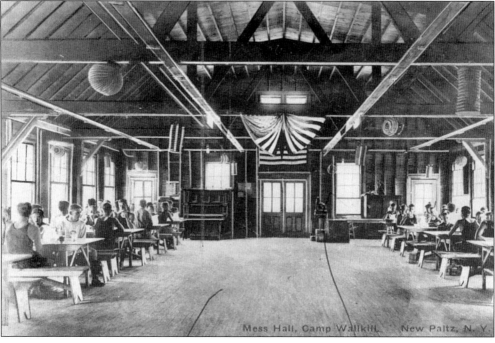

New Paltz Garden Club members volunteered to landscape a part of the new community park in 1955. Boys from the Phi Eta fraternity are shown transplanting trees in the new park under the direction of Mrs. Keith Smiley. In the background is the new three-sided pool from which one could swim out to a three-acre pond. Eventually, a fourth wall was built and a filtration system added. (Photograph by Erma DeWitt.)

The original Moriello pool and bathhouse were located to the west of the present pool complex. In 1956, the board of directors unanimously approved naming the park the Mike Moriello Memorial Park. Mike Moriello, who had been a member of the committee to find a suitable spot for the community park, was instantly killed in a plane crash while spraying his orchards in April 1955. (Photograph by Erma DeWitt.)

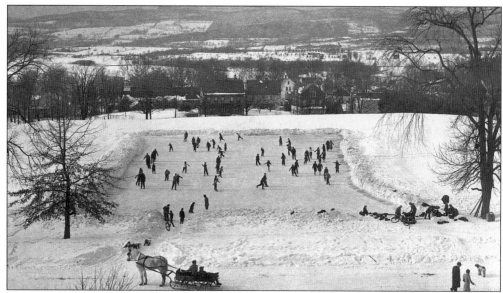

Laura Hasbrouck Varick deeded this parcel of land to the village for a public park. Tennis courts and a summerhouse were constructed in 1923 and 1924. A park committee planted barberry bushes, yucca, and iris. In 1945, the fire department designed this ingenious outdoor ice-skating rink. Similar rinks have been constructed through the years at the Jean Hasbrouck Memorial Park. (Photograph by Erma DeWitt.)

The Red Sox were the champions of the New Paltz Little League for the 1961 season. They defeated the Giants 8-5 in the championship game held at the Jean Hasbrouck Memorial Park, also known as the Campus School field. The winning Red Sox pitcher was Kevin Gibbons, with help from reliever Ralph Travis. Larry Pedersen took the loss. The four other Little League teams were the Yankees, Indians, Dodgers, and Cardinals. (Courtesy of Marjorie Ackert.)

This group of New Paltz Girl Scouts visited the United Nations on their summer trip to New York City in 1958. They also toured the Museum of Natural History and the Planetarium that day. Girl Scouting began in New Paltz in 1918, with Mrs. Montgomery Storr as one of the early leaders. In September 1937, Lillian Campbell formed and led the first Brownie Scout Troop. (Courtesy of Nina Siegel.)

Jan Shuster (front left) hammered steadily throughout the afternoon during the May 1993 planking party on the old Springtown railroad bridge. Shuster and skilled carpenters from the Woodcrest Bruderhof community in Rifton were among hundreds of volunteers who helped to convert the abandoned Wallkill Valley Railroad line into a 12.2-mile-long linear park. Wallkill Valley Rail Trail traffic now consists primarily of walkers, runners, bicyclists, and horseback riders. (Photograph by Lauren Thomas.)

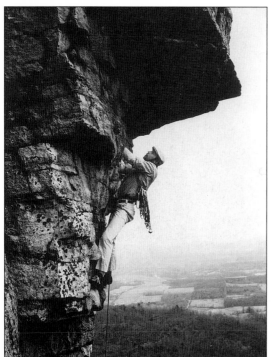

Henry Barber joined a small, established community of technical climbers in a sport pioneered by Fritz Wiessner and Hans Kraus in the Shawangunks in the late 1930s and 1940s. Photographer Paul Potters captures Barber, a bold, talented climber, during the 1974 first ascent of a historic route in the "Gunks." The now famous climbing area of quartz conglomerate cliffs extends along several ridges in the town of Gardiner about six miles west of New Paltz. (Courtesy of Dick Williams.)

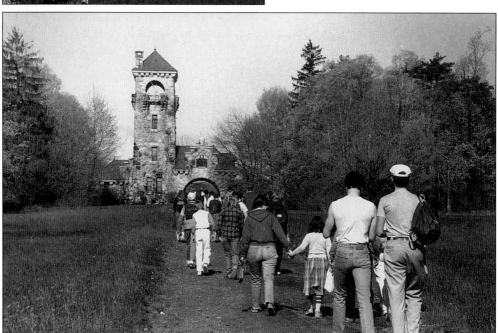

Walk for Hunger participants raise thousands of dollars each year for local and world hunger relief. In 1984, their 18.6-mile route passed through the Mohonk Testimonial Gateway before continuing along the former stage road to Mohonk and trails beyond. Erected in 1907 with funds donated by Mohonk guests, the landmark gateway tower was built to honor Mohonk's founder, Albert K. Smiley, and his wife, Eliza Smiley, on their golden wedding anniversary. (Photograph by Jon Margolis.)

This summerhouse was built on the cleared summit of Guyot's Hill in 1886. Named for Princeton professor and geologist Arnold Guyot, the hill is now overgrown with heavy underbrush and trees. Both the spectacular view and the summerhouse are gone. The 1882 carriage trail remains a favorite with hikers and cross-country skiers. It is believed that Guyot, a Mohonk guest, helped with the layout of the trail. (Courtesy of Mohonk Mountain House Archives.)

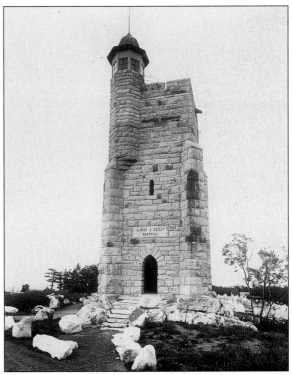

Rising from the high point in the Shawangunks now called Sky Top, this stone tower designed by Boston architect Francis E. Allen took more than two years to build. The tower, visible from countless New Paltz vantage points, was fashioned from stone quarried on the site. The tower with its observation cupola was dedicated in 1923 as a memorial to Albert K. Smiley, the founder of Mohonk. (Courtesy of Mohonk Mountain House Archives.)

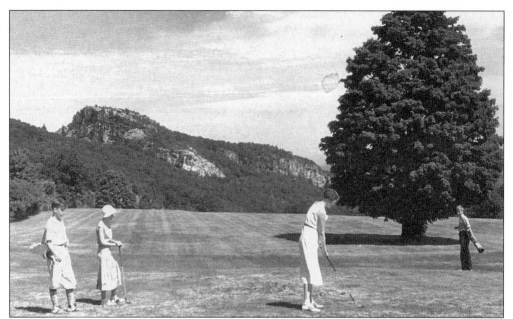

Mohonk established the nine-hole Mountain Rest Golf Course in 1897. Twenty-eight years later, the resort expanded the course to 18 holes, which included the lower Hillside Bonticou section. Playing the first Bonticou hole in 1932, these women are in for a challenging afternoon. The Bonticou section, which closed permanently in 1968, had been open to the public on weekdays since 1931. (Courtesy of Mohonk Mountain House Archives.)

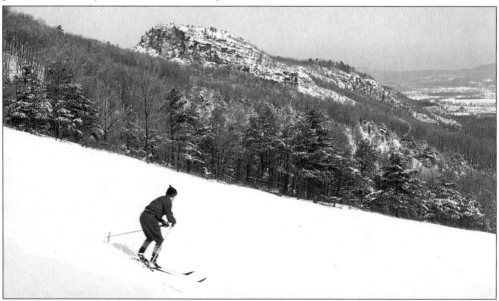

This 1932 photograph predates Mohonk's downhill skiing venture on the eastern slopes of the Shawangunks. The Bonticou Ski Center opened in the mid-1960s, complete with rope tow, T-bar, and a cozy lodge with fireplace. Enthusiastic local support, spearheaded by Bud Ingraham, founder of the Shawangunk Mountain Ski Club, and ski center manager Joe Donahue, was not enough to counter a string of snowless seasons. The operation was dismantled by 1972. (Courtesy of Mohonk Mountain House Archives.)

Formerly the site of a 19th-century water-powered sawmill, Split Rock on the Coxing Kill has been a favorite destination for generations of swimmers and picnickers. The swimming hole, pictured here c. 1945, is now located on the Mohonk Preserve, the largest privately funded preserve in New York State. Established in 1963 as the Mohonk Trust, most of the present 6,400-acre preserve was originally part of Mohonk Mountain House property.

These cross-country skiers and snowshoers followed ungroomed trails to explore the wintery Shawangunks in the early 1930s. Before 1900, Mohonk and the adjacent Minnewaska resort began to construct a network of connecting carriage trails on the Shawangunk Ridge. The nearly 75-mile carriage trail system, along with many more miles of footpaths, attracts thousands of cross-country skiers and hikers to the area each year. (Courtesy of Mohonk Mountain House Archives.)

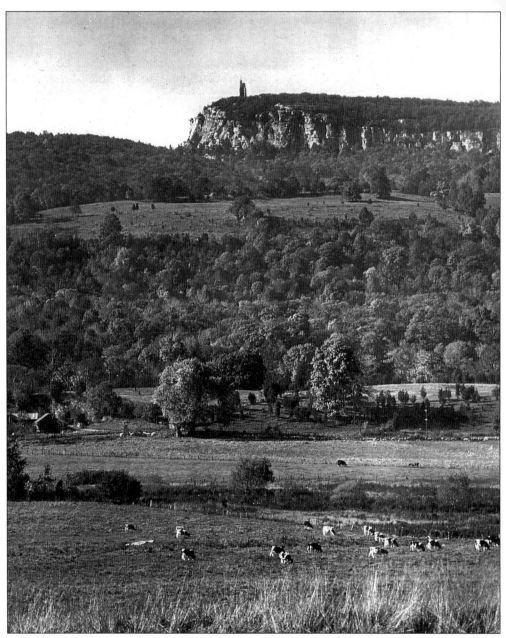

In 1887, Philip H. Smith wrote in *Legends of the Shawangunk*, "The Shawangunk is a vast amphitheater of rocks piled into the most fantastic shapes, with forests covering its crests and slopes, and sporting the exuberance of Nature's own flower-garden. Here the arbutus, the azalea, and the laurel, successively clothe the sides with vernal beauty. The summits overlook the valleys of the Rondout and Wallkill, beautiful as Paradise, where lie the great grazing and dairy farms of world-wide celebrity; while eastward can be traced the valley of the Hudson. . . . From these airy heights mountain views may be seen such as will strike the beholder with astonishment."

ACKNOWLEDGMENTS

In the beginning, we talked about the book that the two of us were planning to publish. However, within a few weeks, it was evident that a full-blown project involving the entire community had blossomed. When approached, many individuals eagerly helped with the search for historically important photographs. Others were extremely helpful with informative identification, information, and dating.

The direct result is *New Paltz*, a book richer for our community's overwhelming generosity, trust, and support. A rewarding bonus has been the addition of nearly 100 copy images to the Haviland-Heidgerd Historical Collection's photographic collection. We have used the phrase "courtesy of" following captions to acknowledge photographs that were loaned to us for specific use in this book. All other photographs are the property of the Haviland-Heidgerd Historical Collection. Photographers have been identified whenever possible, with special appreciation for H.L. Schultz and Erma DeWitt, whose documentary work has helped to tell the story of this community. All of our work is informed by our visionary mentors, William Heidgerd, founder of, and Irene Martin, director emeritus of the Haviland-Heidgerd Historical Collection. We both were fortunate to have worked closely with them for many years.

We are especially grateful for the encouragement and support given by Elting Memorial Library's board members Sally Rhoads, Lynn Bowdery, Mary Ottaway, and James Bacon. We could not have completed this book without the invaluable expertise of photographer Lauren Thomas in reading images and making prints from old negatives. We value the patience and good humor of Nick Driano, the laser copy wizard of Manny's Art Supplies, who has worked carefully with hundreds of our priceless photographs. We would like to also give special thanks to Alfred Marks, Dennis O'Keefe, William Rhoads, and Marie Wiersum for their generosity. Our husbands, Walter Tanczos and Rick Ryan, surely could not have predicted what they were about to experience. Both have nevertheless managed to smile, joke, take messages, listen sympathetically, and give loving support while counting the days to our deadline.

The following list of people involved in this project is very meaningful to us because it really does reflect the community we call home. A heartfelt thank-you to Linda Ackert, Marjorie Ackert, Marsha Barbarito, Ruth Berg, Mary Berger, Stuart Bigley, Ralph Buchanan, Geraldine Buck, Brad Burchell, Barbara Burge, Margaret Coats, Mary Debelack, Betty DuBois, Emily Fairweather, Carol Felter, Camille Fischer, Glenn Gidaly, John Giralico, Stewart Glenn, Harvey Gregory, Dan Guenther, Gertrude Holden, Mikhail Horowitz, Bud Ingraham, William Irwin, John and Katia Jacobs, Judith Jaeckel, Marie Jansen, Bob Krajicek, Joan LaChance, Steve Ladin, Bob Larsen, Jay LeFevre, Susanna Lent, George Mackey, Rachel Matteson, Doris McElhenney, Mildred McGloughlin, Martha McKenna, Heinz Meng, Joyce Minard, Fr. Maurice Moreau, Sheila Moriello, Jack Murphy, Richard Natoli, Rosalie Nelson, Esther Ott, James Palkowics, Kristin Raubenheimer, David Ruger, Haig and Tor Shekerjian, Rose Shuart, Nina Siegel, Judy Sigunick, Sam Slotnick, Catherine Smith, Joe Smith, Susan Stegen, Linda Tantillo, Richard Tofte, William Tozzi, Rev. David Trauffer, Trudy Unger, Vivian Wadlin, Carol Warren, Dick Williams, Donna Ziegler, and Jay Zimmerman Jr.

—Carol A. Johnson and Marion W. Ryan

Suggested Readings

Beers, F.W. *County Atlas of Ulster, New York*. New York: Walker and Jewett, 1875.

Benepe, Barry, ed. *Early Architecture in Ulster County*. Kingston, N.Y.: Junior League of Kingston, N.Y., 1974.

Borenstein, Walter, and Audrey Borenstein. *Through the Years: A Chronicle of Congregation Ahavath Achim, 5725-5750*. New Paltz, N.Y.: 1989.

Burgess, Larry E. *Mohonk: Its People and Spirit*. Revised in 1993, 4th printing with new foreword in 1996. Fleischmanns, N.Y.: Purple Mountain Press, 1980.

Fagan, Jack. *Scenes and Walks in the Northern Shawangunks*. New York: New York-New Jersey Trail Conference, 1998.

Harp, Peter H. *Horse and Buggy Days*. New Paltz, N.Y.: 1994.

Hasbrouck, Kenneth E. *Historic New Paltz*. New Paltz, N.Y.: 1959.

Hasbrouck, Kenneth E., and Erma R. DeWitt. *The Street of the Huguenots*. New Paltz, N.Y.: 1952.

Hauptman, Laurence M. *The Native Americans: A History of the First Residents of New Paltz and Environs*. New Paltz, N.Y.: Haviland-Heidgerd Historical Collection, Elting Memorial Library, 1975.

Heidgerd, William. *Black History of New Paltz*. New Paltz, N.Y.: Haviland-Heidgerd Historical Collection, Elting Memorial Library, 1986.

Hewitt, Charles Edward. *"The Spirit of Penn.": A Tale Founded Upon the Faith of the Quakers*. New York: J.S. Ogilvie Pub. Co., 1909.

Hewitt, Charles Edward. *The Outcast: A Tale of the Mountain People*. New York: J.S. Ogilvie Pub. Co., c. 1913.

Lang, Elizabeth, and Robert Lang. *In a Valley Fair: A History of the State University College of Education at New Paltz*. New Paltz, N.Y.: State University College of Education, 1960.

LeFevre, Ralph. *History of New Paltz, New York and Its Old Families (from 1678 to 1820)*. Albany, N.Y.: Fort Orange Press, 1903. Reprint, Bowie, Md.: Heritage Books, 1992.

Mabee, Carleton. *Listen to the Whistle: An Anecdotal History of the Wallkill Valley Railroad*. Fleischmanns, N.Y.: Purple Mountain Press, 1995.

Moffett, Glendon L. *Down to the River by Trolley: The History of the New Paltz-Highland Trolley Line*. Fleischmanns, N.Y.: Purple Mountain Press, 1993.

The Normal Review, published by classes of the State Normal School, New Paltz, N.Y., 1894–1902.

Osborne, Seward R. *The Saga of the "Mountain Legion" (156th N.Y. Vols.) in the Civil War*. Hightstown, N.J.: Longstreet House, 1994.

Plank, Will. *Banners and Bugles*. Marlborough, N.Y.: Centennial Press, 1963.

Smith, Philip H. *Legends of the Shawangunk*. Pawling, N.Y., Smith & Co., 1887.

Rhoads, William B. *An Architectural History of the Reformed Church: New Paltz, New York*. New Paltz, N.Y.: Reformed Church of New Paltz, 1983.

St. Joseph's Church: New Paltz, New York. South Hackensack, N.J.: Custombook Inc., 1966.

Sylvester, Samuel Bartlett. *History of Ulster County*. Philadelphia: Everts and Peck, 1880. Especially Part Second, *New Paltz* chapter, pp. 2–28.

Weidner, Charles H. *Water for a City: A History of New York City's Problem from the Beginning to the Delaware River System*. New Brunswick, N.J.: Rutgers University Press, 1974.

Williams, Dick. *Shawangunk Rock Climbs: The Trapps*. New York: The AAC Press, 1991.